Brassaï in America, 1957

TEXT BY AGNÈS DE GOUVION SAINT-CYR

Flammarion

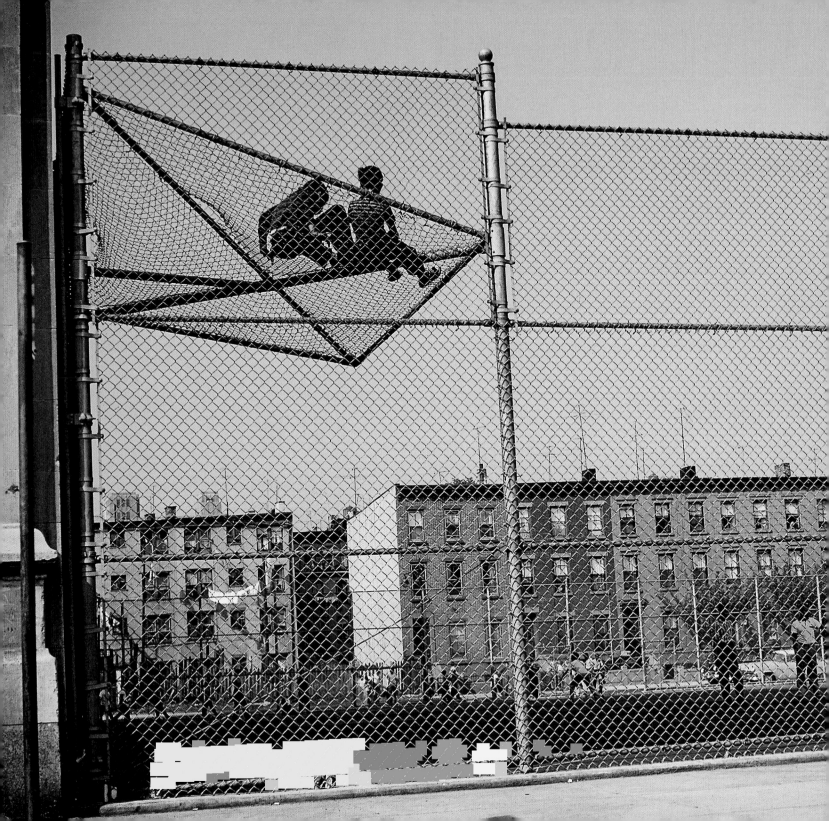

Contents

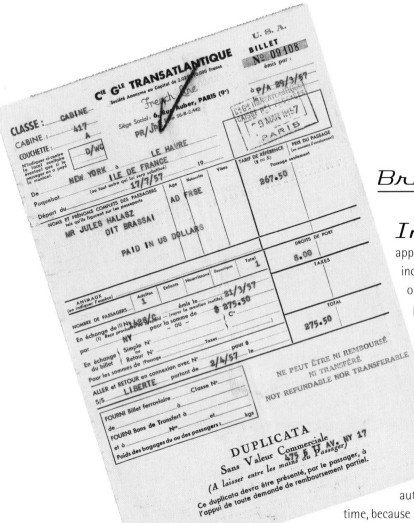

Ticket from the Compagnie
Générale Transatlantique
(the French Line), for Brassaï's
journey with his wife, April 2, 1957

Brassaï in America

In the days following March 18, 1957, when Brassaï filed an application for a visa to the United States, he received an increasing number of reassuring yet inconclusive wires from the other side of the Atlantic. His first great crossing, his first physical encounter with American soil, had been prompted by an attractive offer from the famous glossy magazine *Holiday*, which had given Brassaï free rein to photograph—in his own way—whatever interested him in Louisiana and New York. But for such work he needed a professional visa.

Working papers have always been hard to obtain for America, so it was with relief and a certain exultation that on March 28, just a few days before his departure, Brassaï received a telegram from the Rapho Guillumette photo agency confirming that the authorities in Washington had granted approval. It was high time, because the Compagnie Générale Transatlantique had reserved a cabin on the liner *Liberté* for Brassaï and his wife, Gilberte, who would be accompanying him on his first steps in America. The ship was due to sail from Le Havre on April 2.

Brassaï's trip lasted several months, from April to July, 1957. And it certainly constituted a turning point in the photographer's career from an intellectual and artistic standpoint as well as from financial and personal ones. It might seem strange that Brassaï—who was born in Brassó, Transylvania, in 1899, moved to Berlin in 1921, and then in 1924 to Paris (a long-cherished dream)—had never

Document from the Compagnie
Générale Transatlantique

visited the United States, where he had many friends and relations, notably a group of Hungarian artists and intellectuals who had fled either the horror of European anti-Semitism or the deepening economic crisis. Nevertheless, a certain anxiety can be detected in a note he wrote to Frank Dobo just before his departure. "I'm a little alarmed at the idea that on April 2 I must leave Paris for three months. But I'll also be delighted to finally see New York and greet our few remaining friends."[1]

At the time the United States was a welcoming land brimming with optimism, whereas the Montparnasse of the Roaring Twenties, which had been Brassaï's artistic breeding ground—alongside Man Ray, Kiki of Montparnasse, Henry Miller, and the Surrealists—had been steadily abandoned by his friends and colleagues, notably fellow photographers André Kertész, Ylla, and Ergy Landeau, his literary agent Frank Dobo, and his photographic agent Charles Rado, the founder of the Rapho Guillumette agency. So on April 8 Brassaï finally arrived in New York, where a room had been reserved for him in the Beekman Tower Hotel by Carmel Snow, editor-in-chief of *Harper's Bazaar* since 1932. The Beekman Tower was well located and convenient, and the Brassaïs stayed there until April 21, when they left for Louisiana, where the photographer had scheduled a six-week stint. Snow, sorry she couldn't greet them in person as she had to attend a Dior show and a charity dinner in Chicago that evening, sent a large bouquet of flowers to their hotel room. Brassaï planned to return to New York after his southern sojourn, then hoped to spend nearly a week in Chicago, for mainly personal reasons, before returning once again to New York where he was due to sail from quay 88 at 11:30 a.m. on July 19, 1957.

1. Brassaï, letter to Frank Dobo, March 19, 1957.

This important, constantly postponed trip to the New World presented a contrast with Brassaï's life-long dream of Paris: since the age of four he had been a Parisian in heart and mind. His family had lived through the Austro-Hungarian empire's annexation of Transylvania several decades earlier and, like many middle-class intellectuals, spoke both Hungarian and German yet remained profoundly Francophile, and indeed spoke French. His father taught French at a university and managed to obtain, "by heaven knows what miracle," sabbatical leave to continue his research in France. Thus the entire family moved to Paris for the year 1903. Although very young at the time, the experience left its mark on the boy. In an unpublished, handwritten note he recalls the hackney cabs stationed in front of their apartment on rue Monge, as well as his strolls through the Luxembourg Gardens "dotted with chairs, old men, and children with balls," where he played admiral in command of the squadron of small sailboats in the ornamental pool. He also rode in a carriage down the Champs-Elysées to taste the crème caramel served by Paul, a waiter with a large moustache. All these scenes would later resurface in Brassaï's photographs.

And while he was happy to visit museums with his parents, it was the open-decked Madeleine-to-Bastille bus that he made his main vantage point, from which he observed that "the hierarchy of head gear, from top hats and derbies to panamas, boaters and caps, lent greater character to the crowds."[2]

Letter from the French Line notifying Brassaï of the date of his return to France, July 17, 1957

2. Brassaï, "Souvenirs d'enfance," *Brassaï* (Paris: Éditions Neuf, 1952), and notes from private archives.

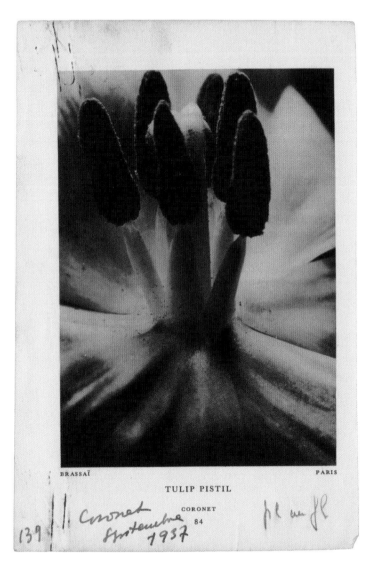

BRASSAÏ PARIS

TULIP PISTIL

CORONET 84

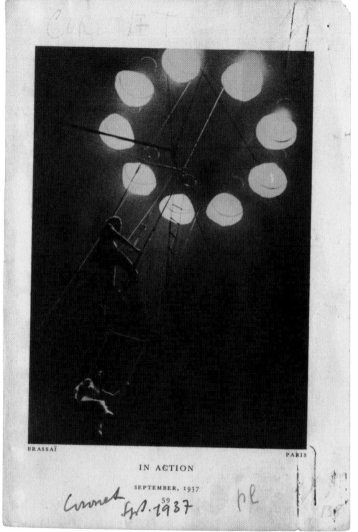

BRASSAÏ PARIS

IN ACTION

SEPTEMBER, 1937

59

Thus from childhood Brassaï enjoyed the waning years of the Belle Époque in Paris, where life seemed easy, frivolous, and fun, where the family friends were musicians, writers, and artists. This was also where stranger, more surprising figures—from the hidden Paris whose bard Brassaï would become—appeared worthy of interest, and above all where he would acquire the idea that he had to observe in order to understand.

So when he left the academy of fine arts in Budapest in 1921, Brassaï informed his parents that he wished to complete his education in Paris, the city that was then the capital of contemporary art, where he felt his talent could blossom. However, coming from a country that had belonged to the enemy coalition during the war and having served in the Austro-Hungarian cavalry, he was not allowed to enter France. Failing Paris, Brassaï decided to head to Berlin, where he enjoyed a student life among a community of artists and musicians that included Lázló Moholy-Nagy, Wassily Kandinksy, Oskar Kokoschka, Edgar Varèse, and his friend and confident the artist Lajos Tihanyi, whom Brassaï would finally join in Paris in 1924.

"Here I am in Paris at last," he wrote to his parents on February 29, 1924. He thus began a professional career as a journalist for German and Hungarian magazines while he conscientiously improved his French—five words a day from a list drawn up from restaurant menus, posters, and graffiti. He not only learned terms such as *giton* (catamite), *mastroquet* (publican), *gringalet* (puny runt), and *escogriffe* (beanpole), but also language whose source is not hard to guess: "a quiver of pleasure, a sensual curiosity," and "I didn't tie one on." Brassaï's letters to his parents shed light not only on his concerns but also on his working and creative methods.

Since he had temporarily stopped painting and drawing, living on a meager journalistic income—or often by his wits—Brassaï arose at noon and went to bed with the first rays of dawn. He steeped himself in the atmosphere of Paris at night, spending entire nights with friends and seeking the sensuality of prostitutes. But above all he observed the city and its denizens—indeed, its toiling masses—which so fascinated him. Although he realized that earning a living was crucial to making his Paris plans come true, he was annoyed that he could not express his artistic

Facing page: Brassaï's first publications in *Coronet* magazine, September 1937

talent for lack of mastery of the language and the social machinery. For the moment, he wrote to his parents with disarming insight that the equation "talent = Paris = success" would remain an illusion unless it was accompanied by a network of connections that helped him to become known and recognized. "The most important thing is that I'm well connected now. Paris was an unavoidable necessity in order to achieve this, but only this.... [T]he hour of redemption is near."[3] Yet he was far from thinking of seeking an international audience, much less one in the United States, where he had no backing and knew neither the language nor the culture. With a determination and rage that sometimes exploded, he pursued a long, slow process of maturation that ultimately led to success. Thus as early as June 1924 he wrote to his parents that, "it would be a mistake to assume that all the months I've spent here have been wasted time. I haven't been painting and I haven't been drawing. Even the last two hectic weeks were more beneficial than they would have been had I been painting, and I am not talking about money. Could I have done anything wiser in the first few months than to do nothing? Nothing could have been more productive.... There is, indeed, an abundance of things that demand one's attention here, particularly for a person like me, who is intrigued by every particle of this living monster, its outside, its inside, the way it breathes, lives, and moves [... and by] the characters who pass before me, for a moment, in the surging crowd."[4]

Time was thus clearly a key concept for Brassaï—the time that was passing, the time he lacked, the time to steep himself in things. His entire life as an artist would be governed by a sense of urgency, even in his final years when he would "save" time in order to implement the projects he listed so passionately. He referred to Goethe, his mentor when it came to philosophy, to explain his need to construct himself over time. As he wrote in one of his notebooks, "My ten years spent in Montparnasse in a kind of carefree absorption from 1922 to 1932 correspond more or less to the ten years Goethe spent in Weimar, which remain a puzzle to his

3. Brassaï, *Letters to My Parents*, translated from the Hungarian by Peter Laki and Barna Kantor (Chicago: University of Chicago Press, 1997), p. 179; *Letters....*, p. 72.
4. Ibid.

biographers. Ten years of feverish, muddled preparation, of scattered, fragmented activity, without a single completed project."

As Brassaï steadily moved away from the somewhat cozy atmosphere of Paris art studios, even before he began taking photographs, he was able to analyze with striking clarity his own creative process, whether it concerned writing or making pictures. And yet his awareness that he had to spend a long time over each work, to carry out extensive research on the context (to which his documentary notes and the books on his own shelves provide eloquent testimony), and then to observe again and again, analyzing and circumscribing his subject, explain his reticence to accept commissions in America.

For the moment, however, we are still in the early 1930s. Brassaï, who had just started taking photographs in order to illustrate his own articles, sowed the seeds of long-term contact with America thanks to the acquaintance, friendship, and personal intervention of three key characters in this story: Henry Miller, Carmel Snow, and, somewhat later, Edward Steichen.

Brassaï dates his first meeting with Miller to 1930, at the Dôme in Montparnasse where his friend Tihanyi introduced him to "the spitting image of Alfonso XIII—minus the pencil moustache." Brassaï would "never forget the first sight of his rosy face emerging from a rumpled raincoat: the pouting, full lower lip, eyes the color of the sea. His eyes were like those of a sailor skilled at scanning the horizon through the spray."[5] Miller had fled New York and his wife June, with whom he no longer got along; he felt crushed by the city, obsessed by his wife's passion for another woman, and sucked dry by his isolation. He came back to life in the "euphoria, liberty, and nonconformity" of Montparnasse where he found people of his own kind with whom he could have a sensible conversation, even if his French was still very

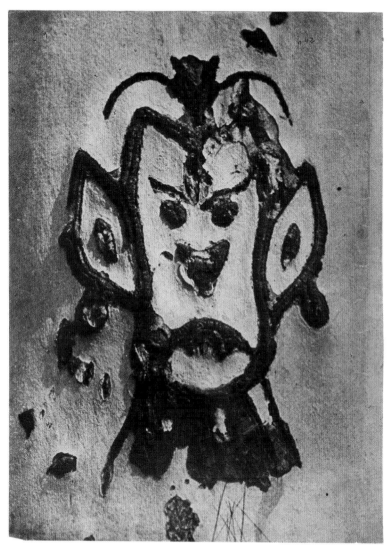

"Graffiti", reproduction in *Harper's Bazaar* magazine, July 1953

5. Brassaï, *Henry Miller: The Paris Years,* translated by Timothy Bent (New York: Arcade, 1995), p. 4.

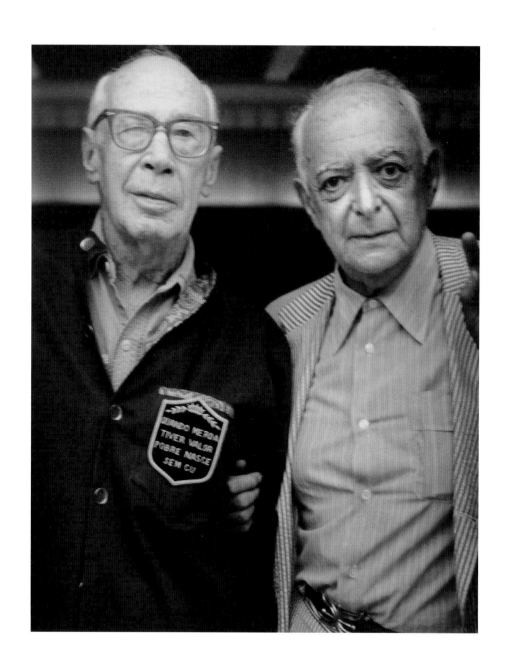

limited.[6] At the same time, Brassaï was searching for the artistic tools best suited to his own quest, and he sensed that photography was the very thing that would enable him to express his vision of a vanishing society. Having absorbed countless images of nocturnal life, Brassaï wondered how he could set them down. That led him to photography, even though, as a "non-art," it had never been one of his interests. Thus Miller and Brassaï were both assailed by doubts, both were suffering the throes of creativity; a symbiosis between their two strong personalities sprang up right from their first encounter, and the brief letters written on stationery from cafés such as Le Dôme, Le Select, or La Coupole—which supplied paper freely, they realized—testified to their main concerns: food, sex, and art. As Miller picturesquely put it in one of these notes:

Dear Halász [as Brassaï was then known],

Today completely broke! If you have anything—a ten-franc coin for example—send it to me this afternoon. And I will thank you humbly and joyously and loyally.

Your Miller (who has not yet died of hunger)[7]

There followed long conversations and endless nocturnal wanderings from Montparnasse to Montmartre, during which the men discussed fundamental philosophical questions of life, death (notably when returning from Tihanyi's funeral), and love (in the course of their affairs), but also aesthetic issues raised by literature, music, and contemporary art.

The correspondence between the two men over a forty-year period testifies to the similarity of their viewpoints. In Brassaï's photographs Miller saw everything he loved about Paris, notably the waning glow of a carefree, bohemian—indeed outcast—society. Miller wrote that in Brassaï he met "the man who like myself had taken in Paris without effort of will, the man who, without my knowing it, was silently slaving away at the illustration of my books."[8]

Facing page:
Henry Miller and Brassaï
in Pacific Palisades,
June 28, 1973

6. Brassaï, *Henry Miller: The Paris Years*, p. 9.
7. Undated letter, reproduced in Brassaï, *Henry Miller: The Paris Years*, p. 72.
8. Henry Miller, "The Eye of Paris," reprinted in Henry Miller, *The Wisdom of the Heart* (New York: New Directions, 1941), p. 179.

This theater of experiences would soon give birth to Miller's *Quiet Days in Clichy* and *Max and the White Phagocytes* and to Brassaï's *Paris by Night* and *The Secret Paris of the '30s*. In contrast, the harshness of life in New York for the less fortunate was something that Miller, who blossomed in Paris, would often mention, as though getting something off his chest—and prompting Brassaï to comment: "In Europe, poverty was purely a matter of bad luck; in the United States it was a sign of moral defect, a badge of shame that society could not pardon.... [This contempt] was what he had had to escape from. Madness or suicide were the alternatives."[9]

Miller's constantly repeated descriptions of a narrow-minded American society, of the hostile, indeed violent city of New York, and a feeling that contempt could kill in America, would subtly percolate in Brassaï's mind, influencing him to the point where, thoroughly aware of his own talent but sensitive to criticism, he decided that he would go to the United States only once so he could reap the fruits of his labor, once his reputation was well established. He would wait for more than twenty years.

Some of Brassaï's subconscious oversights with regard to America should probably also be viewed in light of Miller's hostility toward his home country at that time; thus when *Paris by Night* was being prepared for publication, Julien Levy suggested organizing a show of six "evenings" in his New York gallery, initially scheduled for March 1932 and then, as time slipped by, for October of that same year. Brassaï was then under contract to Alexander Korda, another Hungarian, who asked him to work on the film *The Girl from Maxim's*. The work would have been demanding but Brassaï was already in the habit of doing his darkroom work during the night; yet when Levy pressed him to send the prints for a show that would, understandably, be "very important for him"— indeed was more important than the Korda film—Brassaï simply let more time slip by and wound up canceling the project. "I couldn't deliver the material for the exhibition because of my contract with Korda," he wrote to his parents. "This was a serious mistake. My name could have become known in America as early as 1932."[10] Although aware

9. Brassaï, *Henry Miller: The Paris Years,* p. 7.
10. Brassaï, *Letters...,* p. 259.

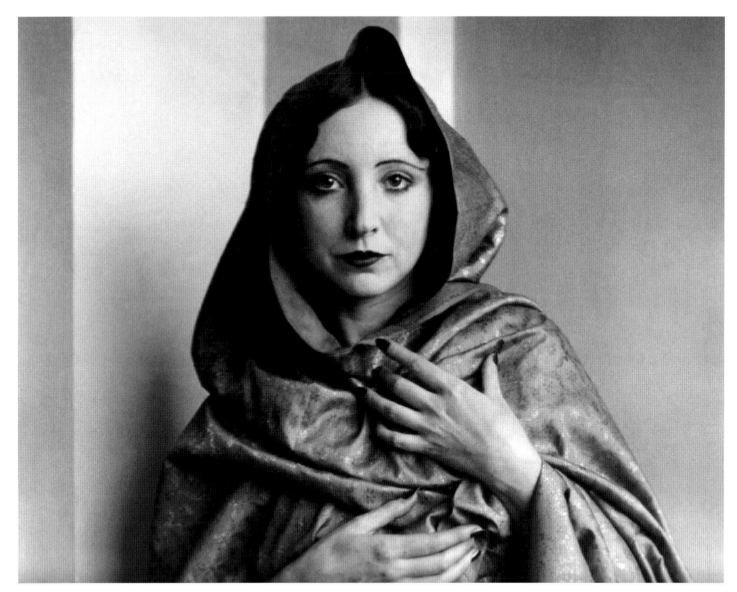

Anaïs Nin photographed by Brassaï

of the quality of his own work, Brassaï was not yet ready to confront the American public and critics.

Similarly, even after Miller had been living at Big Sur for several years, Brassaï employed a pretty flimsy excuse to avoid attending the opening of an exhibition in which his work was included, *Post-War European Photography*. In a letter dated February 12, 1952, he told Miller, "I had intended to go to America to see the exhibition of my photos at MoMA but the show was postponed till December, and I'm afraid of traveling in winter. But we've decided we'll make the trip some day because you can't die without having seen New York and Big Sur."

In fact, at that time Brassaï had begun sculpting again—which became an obsession—whereas long trips made him nervous. He preferred to keep in touch with Miller through regular, attentive correspondence because he knew that they both freely expressed their thoughts in an epistolary style very close to speech. Reading the letters between the two artists reveals not only their intellectual exchanges but also their daily concerns—Miller was worried about another war, and was therefore "planting vegetables and fruit trees in Big Sur in case of famine during the coming war." They also discussed financial needs whenever publication of their books was delayed, as in a letter of 1952. "I'm ashamed to accept this gift of fifty dollars.... I'm not all that desperate, though I've had seven tough years." But then Miller added, "but I also have a new wife who is twenty-eight years old." Indeed, allusions to Miller's conquests were as frequent as his games of ping-pong. "I play ping-pong all the time. Winter is our ping-pong season *par excellence*."

The two men mutually supported one another: Miller agreed to write a foreword to the first monograph on Brassaï published by New York's Museum of Modern Art, while Brassaï suggested that Miller, during one of his difficult financial periods, do some work for the French review *XXième Siècle*. And when the Miller couple broke up and Miller mentioned his difficult domestic situation ("I no longer have a home"), Brassaï preferred to rejoice over the end to the censorship and lawsuits that had plagued Miller following the publication of *Tropic of Cancer*. Brassaï knew, moreover, that these letters acted like a "shot of tranquilizers" that eased the depression and distress inherent in his friend's personality.

Brassaï's relationship with Miller also represented a link to all his other close friends who had emigrated to the United States—André Kertész, Fred Perlès, Frank Dobo. America still remained somewhat mysterious to Brassaï, and he was still wary of it.

After his first project with the Julien Levy Gallery in New York fell through, the same thing nearly happened with *Harper's Bazaar*. And yet in 1934 when Carmel Snow—who had been struck not only by his photos of Paris night life but also his spread on the hairdresser Antoine—contacted Brassaï in Paris, he was in dire need of regular income. Still, Brassaï hesitated to accept because he dreaded the constraints of commissioned work—indeed of regular, recurring commissions—especially in the realm of fashion, which seemed superficial to him even though he was already somewhat familiar with it. As chief of *Harper's Bazaar*, however, Snow had just hired Alexey Brodovitch as art director and Beatrice Kaufman as literary editor in an effort to provide the magazine with an artistic and literary content it had previously lacked. She solicited writers of the stature of Carson McCullers, opened her pages to Salvador Dalí and Marc Chagall, and recruited young photographic talent including Louise Dahl Wolfe, Martin Munkácsi, and Brassaï in order to give the magazine's articles greater visual impact. Brodovitch, meanwhile, was given free rein to lay out the pages and choose the pictures. Snow assumed full responsibility for her policy and won over Brassaï by guaranteeing him total freedom in the choice of subjects he submitted to *Harper's Bazaar*, confirming that he would not have to cover fashion stories. The contract was a handsome one for the times, guaranteeing Brassaï publication in every issue; he could thus boast that America's biggest fashion magazine—a rival to *Vogue*—wanted to publish two full-page photos by him every month, for which he would be paid three thousand francs. And yet in a letter dated October 17, 1935, he confessed to his parents that, "this deal has been delayed for a whole year, through my own fault. I took the first photo for them a few days ago: couples coming down the steps of the Opera dressed in evening attire."[11]

Front cover of Brassaï's exhibition at MoMA in New York, 1968

11. Brassaï, *Letters...*, p. 213.

Publication in *Harper's Bazaar*, 1953

From that time up to the mid-1960s (following Snow's death and Brodovitch's replacement by Marvin Israel), Brassaï made regular contributions to *Harper's Bazaar*, proposing subjects as unusual as midnight mass in Baux-de-Provence, the medieval hospital in Beaune, an "Ideal Palace" built by an eccentric postman known as Le Facteur Cheval, the Bomarzo gardens, a story on fortune-tellers, and another on Holy Week in Andalusia. The magazine moreover dispatched him to exotic destinations such as Bali, Bahia, Turkey, and Snow's own country of Ireland. If the photographs concerned more ordinary subjects, such as portraits of artists or cats, discussion might arise: a story on Giacometti needed further development, Maillol should pose with his model, a final portrait of Thomas Mann needed to be taken. Better still, a delightful correspondence discussed the need—or not—to do a portrait of Colette's cat, which was "famous" but perhaps "too aristocratic" to be pictured alongside gutter cats. Brassaï was asked to resolve this tricky question. "Could you get in touch with Madame Colette," wrote Snow to Brassaï on January 31, 1939, "and ask permission to take a picture of her cat? That cat is famous, and I think we should have it...."

Brassaï was never short of ideas, and thus he steadily built up a store of photographs that would be published in later books such as *Fiesta in Seville* (1952, English edition 1956) and *Artists of My Life* (1982).

Their relationship was amicable, trusting, even close. Thus Brassaï was the first to learn in June 1945 that the Paris bureau of *Harper's Bazaar* would be reopening and commissioning work from its former contributors. And when Brassaï told Snow in 1951 that a Swiss manufacturer was making fabrics based on his photographs for Dior and Balenciaga, she cabled back the following message: "Thrilled about your news regarding Swiss fabrics will surely do something about them in Bazaar Stop Love to you and your wife Stop." There were many attentive little gestures such as telegrams of congratulations or praise for photographs, plus invitations to sundry events in Paris, Ireland, and even New York for the wedding of Snow's daughter, which were answered by the dispatch

of flowers—roses or snowdrops—to Snow on her arrival in Paris for the week of fashion shows. She was furthermore aware of Brassaï's financial difficulties and didn't hesitate on occasion to accept and pay for pictures she knew she could never publish.

While this professional connection remains exemplary, Brassaï found other unexpected outlets in America, either in the advertising sphere (via Charles Rado's agency) or with magazines that wanted to work directly with him. In August 1937 Brassaï wrote to his parents that, "An American periodical, the Chicago *Coronet*, has bought more than two hundred photos from me at eight dollars each.... Through Rado's agency, I sell photos, mainly to advertising agencies, for four to five thousand francs a month.... In addition to French periodicals, there are the sales through my London, New York, and Berlin agents. The stress is proportionate, of course...."[12]

Although Brassaï's reputation was becoming well established in the American press and advertising sectors by the late 1930s, he sought above all the artistic recognition that he let slip through his fingers when he canceled the show at the Julien Levy Gallery in New York, as mentioned above. Although, critical reception in the United States was largely positive to *Paris by Night,* it did not definitively situate his work in the realm of art, even if Stieglitz was already showing interest in Brassaï's photos. And the critic of the *Chicago Daily Tribune* complained in his column of March 1933 that Brassaï's name appeared in smaller print than Paul Morand's in *Paris by Night,* even though the latter contributed a mere eight pages of routine text to the book.

Brassaï's artistic reputation, however, would grow over time, slowly but surely, through almost continuous inclusion in the major photography shows organized by American museums. First came the group exhibitions generally curated by Steichen when he was director of the department of photography at New York's Museum of Modern Art (MoMA). Steichen was an early, unconditional supporter of Brassaï after having seen his works in the 1932

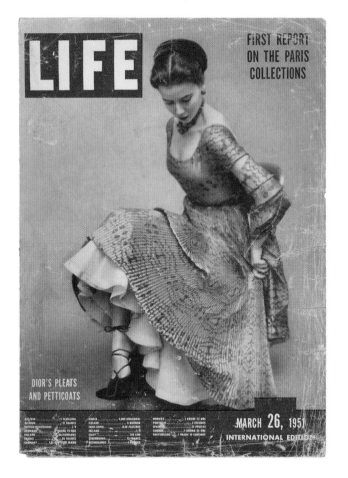

Front cover of *Life*, dated March 26, 1961. Dress by Dior with fabric made by Brassaï

12. Brassaï, *Letters...*, p. 221.

exhibition, *Modern European Photography*. Alfred Stieglitz in turn recommended Brassaï. And while MoMA had already presented his work in the context of *Modern Photography* and The Photo League Gallery showed *French Photographers Today* in 1948, it was Brassaï's inclusion in *Five French Photographers* (1951) alongside Henri Cartier-Bresson, Robert Doisneau, Izis, and Willy Ronis that marked his permanent acceptance in the American art world. Originally, Steichen planned a general show devoted to French photography, and he submitted the idea to Cartier-Bresson and Brassaï, who both felt that it would be more effective to focus on the work of five high-profile photographers. Steichen agreed all the more willingly since at that time MoMA was still reluctant to mount monographic photography shows—a show of this type should therefore draw more publicity and visitors.

The show was an instant hit. The critics were favorably surprised. Reviews were numerous and highly flattering, to the point where Brassaï assumed the role of press attaché in Paris in January 1952, writing to Georges Charensol and Raymond Cogniat, editors of *La Revue des Arts*, "I would like to draw your attention to an event related to French art currently taking place in New York. I am referring to the exhibition of five French photographers at the Museum of Modern Art, which opened on December 18th and runs till February 24th. Too few people in France realize that there is a specifically French art of photography, a kind of photographic school of Paris. Highly thought of abroad, its major characteristics, according to Monsieur Steichen, are: tender simplicity, sly humor, warm earthiness, and convincing aliveness. Over there people look to us for new inspiration, over there people cite us as examples thanks to the freshness, spontaneity, rich ambience, and fine composition of our photographs."

Exemplary in more ways than one, this show prompted Brassaï to reflect on the organization of his works, their format, presentation, and occupation of space. He suggested sixty-four prints on matte paper designed to minimize reflections—black being extremely present in his photos—with no margins, in a 40 x 50 cm format (16 x 20 in.). Forty-three photos were ultimately selected and arranged in themes, placed on a thick wood support that detached them from the wall. It is worth noting that in this instance Brassaï wished to express his

thoughts on his art, and he wrote a manifesto-like text on his conception of photography. Among other things, he asserted that, "If, as a photographer, I had to choose between life and art, I would always choose life first. Because unlike painting, what is magnificent about photography is that it can produce works that are moving solely because of their subject matter. But it should not be forgotten that photography is *also* a visible mark, a surface to be filled, and that in this quality it is *also* tributary to certain aesthetic requirements.... My greatest ambition is to do something new and striking with the ordinary and conventional...."[13]

Brassaï sensed the importance of this exhibition with respect to his future relationship with the American art scene, and his correspondence at the time with Steichen and Rado reveals the care with which he prepared it. So when Steichen not only entrusted him with making the project work but also assured him that his photos were truly striking and strong, congratulated him, and furthermore announced that the show would travel and that a portfolio of thirty to forty pages would be included in the 1953 *US Camera Annual*, Brassaï exulted and immediately informed his father. It is worth noting that from this exhibition onward Brassaï regularly sent reviews of his work to his father—probably because there was no chance that the American press would reach his home town of Brassó, whose name had been changed to Grasul Stalin—as though he sought to convince his father that he had done well to commit himself to photography despite paternal misgivings.

Brassaï remained in contact with Steichen, and when the director of MoMA's department of photography organized the famous *Family of Man* exhibition in 1954, he wished to include prints by Brassaï that he felt went to the heart of the various thematic chapters of his show. To this end Steichen asked to borrow the negatives themselves, in order to make huge enlargements of *Kiss on a Giant Swing* and *Isère Valley*. Brassaï's acceptance was a gesture of trust.

Press release
for the exhibition
at MoMA in New York,
October 23, 1956

13. Statement sent to Steichen, December 10, 1951.

Walls of Paris
by Brassaï

• To the learned they are graffiti; to most, the scrawls and scratches that pass almost unobserved on so many walls, everywhere. These images of fantasy and terror, innocence and gaiety are both a reflection of everyday life and the shadowy kingdom of the subconscious. They are also links with prehistoric man. All through the ages man has left such records. In the grottoes of the Dordogne, Pompeii or the valley of the Nile. Today, the walls of Paris are rich in this bizarre flowering, behind the glittering façade and in the suburban wastes, a step from the Place de l'Opéra or the little bistro. For twenty years the photographer Brassaï has been collecting them for a book. We reproduce some, chiefly by children, of this strange universe of signs and symbols.

Although this is an age of logic and science, great store is set by naive or primitive paintings, as well as those by children and madmen. Their dreamlike fantasy and candor are profoundly significant. Studying these graffiti we sense an emotional undercurrent. Children's paintings show sensuous enjoyment of color, but the graffiti have a far greater dramatic impact: bereft of color they are starkly intense. And when the child, doodling with a blunt knife or stump of chalk, suddenly discovers the phantasmagoria to be conjured from cracks and blotches on an old wall—we see how, his imagination fired, he follows the limitless images of his inner eye.

Reduced to their minimum, graffiti become a language of cabalistic signs. As in any language, there are clichés too. Pierced hearts and crossbones, phallic symbols and forbidden words. Slogans, spells and mumbo-jumbos. Most often, a death's head, a haunting lunar mask. Three dark circles stare out, eyes, mouth, telling of man's primitive anguish, his dread of annihilation; a note of doom among the nursery squiggles.

• The grimacing monkey face, opposite, is chiseled into a plane tree in front of the Hôtel de Ville. Its expression changes subtly as the tree trunk spreads and stretches.
• Above, a bearded monster formed by a slosh of paint effacing the Resistance symbol of the Cross of Lorraine.
• Right, an artist goes to work on a tempting bit of wall.

A. 2124

A. 1689

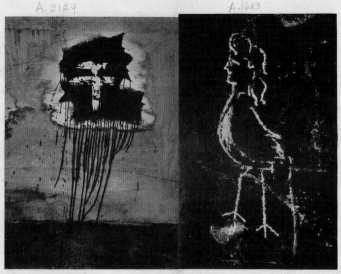

A. 2045

• Above, a literal rendition of what the lady in question is called: *une poule*, which in one sense means chicken, otherwise translates as "a broad."
• Right, a Nazi soldier—a child's vivid impression of the strutting robot figure, its duck-bodied stiffness contrived around the sign of the swastika.

• Opposite, the monster, classically recurrent motif ⟶ in wall drawings. Here, the source of inspiration shows through the finished work: a blemish on the wall which the child darkened to preserve his eerie vision; then laboriously incised its mask form with a sharp instrument.

A. 1769

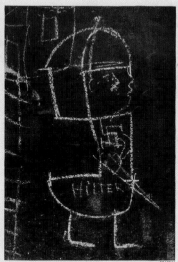

BRASSAÏ

Joint projects then followed one after another. A telegram from Steichen in April 1956 ("Graffiti photos superb Thanks") was soon followed by a wire from Brassaï: "Delighted by your invitation. Sending letter and Graffiti Show mock-up today. Will do utmost to make it work." But 1956 was also the year that Brassaï was making a short film, *Tant qu'il y aura des bêtes* (As Long as There are Animals, sometimes titled *Lovers and Clowns*), which would be selected for the Cannes Film Festival (where it would win a prize), and was having difficulty managing both postproduction of the film and organization of the show. Steichen grew worried but Brassaï made a herculean effort and in June managed to complete a detailed proposal of the exhibition, which he suggested be organized around thematic chapters devoted to the language of walls, to the emergence of faces and figures, and to subjects such as love, death, war, magic, and animals, as seen in a total of 150 prints ranging in size from 24 x 30 cm (9 x 12 in.) to 40 x 50 cm (16 x 20 in.). Alert to the exceptional nature of this body of work, Steichen wired Brassaï in August to say that he would postpone the show until mid-October, not being quite sure about the way in which it should be handled; he added that he wanted to avoid at all costs an exhibition that too closely resembled a book, so he asked that the number of prints be limited to 120 in order to include "some very large pictures which will help give your ideas a greater impact."

Indeed, Brassaï had just sent Steichen a text setting forth those ideas. His work, he explained, would save this graffiti from inevitable extinction and would shed light on "an art of humble people devoid of art education and culture, obliged to invent everything on their own. An unknown, unknowing art." Brassaï felt that walls—whether the walls of a cave or a street—represented the largest museum in the world, evoking the idea of the continuity and eternity of art, a role that was to be underscored through the design of this exhibition. Brassaï was thus the first photographer to meditate on the physical recreation of his work.

Pleased with this project, Brassaï immediately mentioned it to Snow, who in 1953 was the first editor to publish a spread of his graffiti photos in *Harper's Bazaar*. Brassaï told her that he hoped the exhibition would truly reflect "the

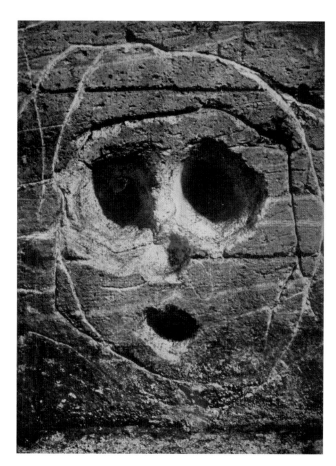

Facing page and above: Pages taken from the issue of *Harper's Bazaar* on "Graffiti", July 1953

magical world of childhood and also the origins of art, such as graffiti's relationship to prehistoric art and trends in modern art."[14]

As a product of popular culture that often reflected poor taste, graffiti continued down through the years to spur Brassaï's meditations on the origins of creativity and the notion of a work of art. Thus in 1958 he wrote in the foreword to a catalogue that, "Since the days when I began taking pictures of graffiti, a development has occurred in contemporary art that is perhaps as important as the advent of cubism: the discovery of the wall by most contemporary painters including Klee, Miró, Dubuffet, and the *Informel,* action, and *Tachisme* artists.... Art has returned to its roots, to the timeless arts and above all to archaic art, to instinctive gestures and primordial marks." After studying these "daubings, scratchings, sprayings, stainings, rubbings, and snatches of bright color all stolen from that peerless master, time, who governs the wall"—those last living traces of earlier inhabitants—Brassaï noted that photographing them in black and white accentuated not only their graphic aspect but also their mystery.

Brassaï's proposal was accepted, and on October 12 "Captain" Steichen wired, "Thanks. Pictures superb. Show will open October 24." He also invited Brassaï to attend the opening. Brassaï nevertheless declined the invitation, detained in Paris by the success of his film and above all by a long visit from his octogenarian father. He was also a little worried about the reception that might be given to what he considered his major experimental project. But the exhibition was soon so popular that Roland Penrose hosted it at the Institute of Contemporary Art in London in 1958. Meanwhile, the book on Brassaï's graffiti photographs would not be published until 1960, in Germany, after countless difficulties.

In fact, Brassaï was lionized by the New York art scene, and his collaboration with Steichen strengthened over time. Professional and personal contact became so frequent that in 1960 "the Captain" suggested to Brassaï that MoMA sell his

14. Letter to Carmel Snow, September 4, 1956.

le 27 Sept. 1956

Via WESTERN UNION

PSN113 NEWYORK 14 26 422P

=CLICHES ARRIVE MERCI=STEICHEN+

Nov. 6, 1957

Dear M. Brassaï,

I should have sent these to you a long time ago, but we have been busy here -- particularly in the past weeks, getting ready for our new exhibition of photographs of New York City.

Would you be good enough to sign these and return them to the Registrar? Thank you very much.

My warm greetings to your wife, and all the best to both of you

E. Koningsberger
Photography Dept.

4 oct. 1956 NFL

Via WESTERN UNION

PSW369 NEWYORK 19 4 1205PM

ANXIOUSLY AWAITING EXHIBITION PRINTS PLEASE ADVISE SHIPPING
DATE URGENT = STEICHEN MODERNART +

12 Octobre 1956

Via WESTERN UNION

PS834 NEWYORK 16 11 210P

MERCI EPREUVES SUPERBS EXPOSITION OUVIRA VINGT QUATRE
OCTOBRE#STEICHEN=

prints, even while acknowledging that the weakness of the market meant that retail prices would have to remain modest, roughly twenty-five dollars per print. Brassaï nevertheless decided to leave management of his U.S. business affairs to his friend and agent, Dobo. Some years later, however, he accepted MoMA's offer and enjoyed limited, if gratifying, sales.

The two men's last collaboration involved the making of a television program in 1963 based on *The Family of Man* exhibition—Brassaï granted his approval, but was not directly involved in the undertaking.

Soon John Szarkowski was named the new director of MoMA's department of photography. In 1966 he informed Brassaï of his desire to buy "a large number of photographs"—in fact, some forty prints—and to use the occasion to organize a major retrospective accompanied by a catalogue featuring the acquisitions. The show was scheduled for October 1968, and although the purchase of the works was deferred due to "lack of funds," Szarkowski assured Brassaï they would still constitute the heart of the exhibition.

Although a large part of the show was devoted to a major group of graffiti pictures, it also included photographs from *Paris by Night* and especially a significant selection stemming from a series dubbed "The Secret Paris of the '30s." But at that time Brassaï was working on the layout of a book based on that still little-known series, and thus he asked that those photos were not reproduced in the catalogue. Obviously, Szarkowski was sincerely disappointed, but he understood Brassaï's reservations and ultimately agreed to the artist's condition. In addition to 112 prints, the show featured Brassaï's short prize-winning film, *Tant qu'il y aura des bêtes* (*Lovers and Clowns*), the only movie he ever made.

In fact, 1968 could be considered a banner year for Brassaï. His retrospective was hailed by critics and then went on to travel for two years, first in Australia and New Zealand, then in Latin America. At the same time he was pleased that La Boetie Gallery in New York decided to show a lesser-known aspect of his oeuvre, namely the sculptures, drawings, and engravings (the notorious cliché-verre works titled *Transmutations*) that he had exhibited the previous year at Lacoste in France under the aegis of Les Contards Gallery. The show included Brassaï's first tapestry based on his graffiti photographs.

Facing page:
Brassaï exhibition at MoMA,
New York, October 23, 1956

Brassaï's oeuvre has subsequently enjoyed a regular, lasting presence on the American art scene, thanks to backing from museums—in particular Santa Barbara, Houston, the Corcoran Gallery, the Getty Museum, and the National Gallery—and from galleries such as Virginia Zabriskie, Marlborough, Harry Lunn, and, more recently, Edwynn Houk.

But to return to an earlier period, the success of his show of graffiti pictures surprised and delighted Brassaï, giving him greater confidence in his artistic status in the United States: this was the moment when he began to realize that he had been permanently accepted by the general public as well as intellectuals in America. And it probably influenced his decision to accept, in 1957, the commission from *Holiday* magazine, which, knowing Brassaï's reticence regarding commissioned work, wisely gave him a great deal of creative freedom to forge his personal vision of the United States. The magazine offered a fee of three thousand dollars for photographs of New York—"notably a very crowded street, I think it was Third Avenue," recalled Brassaï. But he also wanted to go to Chicago, headquarters of *Coronet* magazine, for which he had worked between 1937 and 1940, and above all he wanted to see Louisiana where he could try out his new Leica and do some professional experiments with color film.

Right from the initial, highly symbolic sight of the Statue of Liberty from the bow of his ship, Brassaï's interest was immediately drawn to the graphic presence of skyscrapers, which drew a vertical picture of New York. Whereas he observed Paris from a human height, he was overwhelmed by the pattern of windows, whether lit or not, in a city that he observed with his head constantly in the air. He had to find his bearings in this new configuration, for it embodied an urban project—in both senses of the term—that totally disarmed him. Although he dutifully visited a "crowded" street, Brassaï above all encountered the crowd, he who had always favored the depiction of individuals. For that matter, it is interesting to note that unlike advocates of "street photography" such as Robert Frank, William Klein, and Garry Winogrand, who were leading American photographers of the day, Brassaï remained a fan of a Baudelairean vision of modern life, favoring a sensuality largely focused on women. He always felt that the modern essence of a given

city was embodied by its vision of women. Moreover, Brassaï seemed to share the opinion expressed by Louis Aragon in his foreword to *Une anthologie moderne* (A Modern Anthology): "Instead of worrying about the behavior of men, just watch women pass by." That is what Brassaï had done during his years in Berlin, during long excursions that allowed him to exclaim, when it came to his art: "What rhythm the human body has! I am completely familiar with the structure of the nude now.... I am freely remolding the shapes, even at the expense of anatomy and proportion, if necessary."[15] This idea would recur in a lecture he gave at MIT on May 13, 1977: "I did a series of highly geometric nudes, which I titled *Les Arrondissements,* named after the twenty districts in Paris. But I should mention that it was the 'roundness' of the female body that made me think of this connection." The reasons that prompted Brassaï to take pictures of women in the streets—especially the rounder women who appealed to him—thus become clearer.

Little by little, a new vocabulary emerged from Brassaï's depictions of American cities, because whereas Paris remained for him a city where people posed—the prostitutes who wait, the lovers who kiss, and the tramps who lie dormant all establish a link between the observer and the willingly observed— New York speeded everything up and came alive in a non-stop flow of crowds that jostle and pass by unseeing. Brassaï liked to show Paris at night with its leisurely pace, while in New York he strove to record the bright lights of its urban whirlwind. In order to convey this perpetual movement, Brassaï would place himself in the middle of the crowd, take a frontal picture of a passer-by, and then turn to get a shot of the back and finally, in a zoom-like sequence, get closer to the face that interested him—as seen in the profile of a woman with flowery hat, or in two little girls in white muslin dresses and hats. Brassaï, struck by the abundance of consumer goods, favored repetitive motifs—for example, hats or caps—that occupied almost the entire area of the photograph.

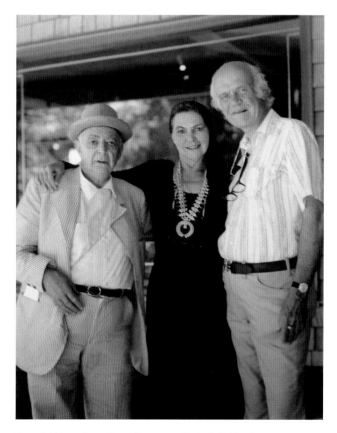

Brassaï, Gilberte Brassaï, and Beaumont Newhall, California, 1973

15. Brassaï, *Letters...*, p. 28.

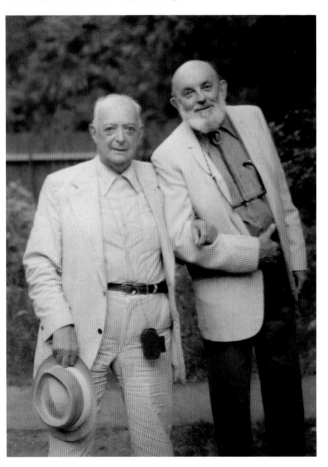

Brassaï and Ansel Adams, Yosemite Valley, 1973

It is clear that Brassaï's visual composition slowly changed, and his corpus of American pictures contains many examples of successive scenes taken from the same spot with identical framing in a very brief lapse of time, evoking a cinematic feel. Of course, Brassaï had spent the previous year working on his film, *Tant qu'il y aura des bêtes,* but up till then it had been rare to find in his work scenes of everyday life presented so systematically in a sequential series, such as children playing and climbing on a statue, little girls parading down the alley of a park, or candid shots of passers-by before a small statue of Napoleon.

Brassaï furthermore displayed striking virtuosity in a series about crossing a bridge, where the beholder follows the progress of old people swaying left and right to the slow pace of their heavy strides—it almost looks like a chronophotograph in disguise.

After coming to grips not only with local architecture—which seems to have interested him primarily for its graphic impact—but also with individuals whose uniqueness he sought to snatch from the crowd, Brassaï had fun taking pictures of unusual situations: he played on the scale between a (short) statue of Napoleon and passers-by, on the phenomenon of visual repetition via baby-carriages of triplets, and on incongruous scenes such as executives relaxing in the sun in front of the New York Stock Exchange or a shot where a Hollywood star literally emerges from a painter's scaffolding.

Brassaï steadily became accustomed to working with unfamiliar light. While his nocturnal photographs set the benchmark for how to use urban lighting (the glow of gas street-lamps, the glare of automobile headlights), and the 1937 Universal Exposition in Paris gave him an opportunity to work with powerful searchlights illuminating the sky and thus redefining the environment, he had not yet had an opportunity to explore slanting daytime light as sliced and filtered by urban architecture. Lighted buildings composed a new heavenly firmament, neons flashed out "continuous entertainment" in night clubs, and above all rays of light surged from the corners of buildings and skylights, all turning New York into a theater of unsuspected shapes.

Once Brassaï reached Louisiana he willingly dropped the urban theme and turned to imagery generated by the Mississippi River—landscapes that glide by

slowly, passengers with time on their hands enjoying a peaceful trip with friends or a lover, and a crowd of copper-skinned bathers who prompted Brassaï to test his palette of colors. Indeed, color was probably the major photographic discovery made by Brassaï in Louisiana. He had in fact briefly experimented with color before leaving Europe, but hadn't had a chance to test the particular qualities of various film stocks. It might be said that he was therefore working "by instinct" in so far as the films were only developed upon Brassaï's return to Paris. The results of these exposures delighted him, and spurred him a few years later to do a color series on graffiti; it would seem, given the few color photographs taken by Brassaï, that he saved color for what he called his "abstract" work.

Brassaï blithely alternated between nostalgic, pastel tones (when picturing the gauzy gowns of pretty co-eds in the former French territory of Louisiana), a nearly monochromatic effect in night scenes, and saturated colors as found in amusement parks (with their rides and shooting arcades), beaches (with their umbrellas), and unusual window displays or gaudily dressed strollers. This ability to capture the shifting tones generated by color when taking pictures of people and things was based, at this particular point in Brassaï's career, on his use of the easy-to-handle Leica, a camera he was employing for the first time. Brassaï's position as observer thus changed—he took pictures faster, from closer up, if always with the same boldness.

It seems he was in his element in Louisiana. He was pleased to discover once again a night life of parties, music, and pretty women, not to mention a more leisurely pace of life and a foliage that harked back to his photographs of entwining, exotic plants as published in *Le Minotaure* in the 1930s.

Brassaï's first trip to America also enabled him to see again or meet in person the friends who had constantly encouraged him, not only Miller, Steichen, and Snow, but also Nancy and Beaumont Newhall, Ansel Adams, and the survivors of the F/64 group, whom he would meet in San Francisco. Furthermore, on a later trip to Washington in 1973 for his show at the Corcoran Gallery, he went on to Carmel, California, to participate in a seminar titled *Creative Experience* (June 18–22) alongside Beaumont Newhall and Ansel Adams, among others. In June he wrote to his brother that, "We spent three days in Carmel, but were literally

kidnapped. I barely managed to slip away for a visit to Big Sur." Big Sur was where his friend Miller, who surprised Brassaï with his "vigor and good humor despite the drawbacks of age," had invited him to come and stay, insisting that "the landscape was worth the trip."

Brassaï's love story with America carried on into 1976 with a show at the Marlborough Gallery in New York. In fact, for several years the Marlborough had sought to organize a show of *Secret Paris of the 1930s*, which Brassaï was then preparing for publication with Gallimard. The agreement charged the gallery with organizing a show that would travel beyond New York to Baltimore, Zurich, Birmingham, the Hague and elsewhere, to coincide with the various foreign-language editions of the book.

The next year Brassaï went back to the United States for a series of lectures on his work. He projected and discussed his photographs before enthusiastic audiences at MIT in Cambridge and Columbia in New York. Faithful to their partnership, in 1979 the Marlborough Gallery organized a celebratory eightieth-birthday show of Brassaï's photographs of artists, most of which had been taken for *Harper's Bazaar.* Along with some of his writings these photos were published in 1982 as *The Artists of My Life.*

Thus ended Brassaï's relationship with America, initially complex and fearful, eventually victorious and confident. In a characteristic quip, Brassaï said, "I'm the opposite of Christopher Columbus—this time it's America who has just discovered me."

Facing page:
The photographer Imogen Cunningham,
photographed by Brassaï, 1973

Page 34:
Self-caricature of Brassaï, private view of the exhibition
at the Malborough Gallery, New York, September 17, 1976

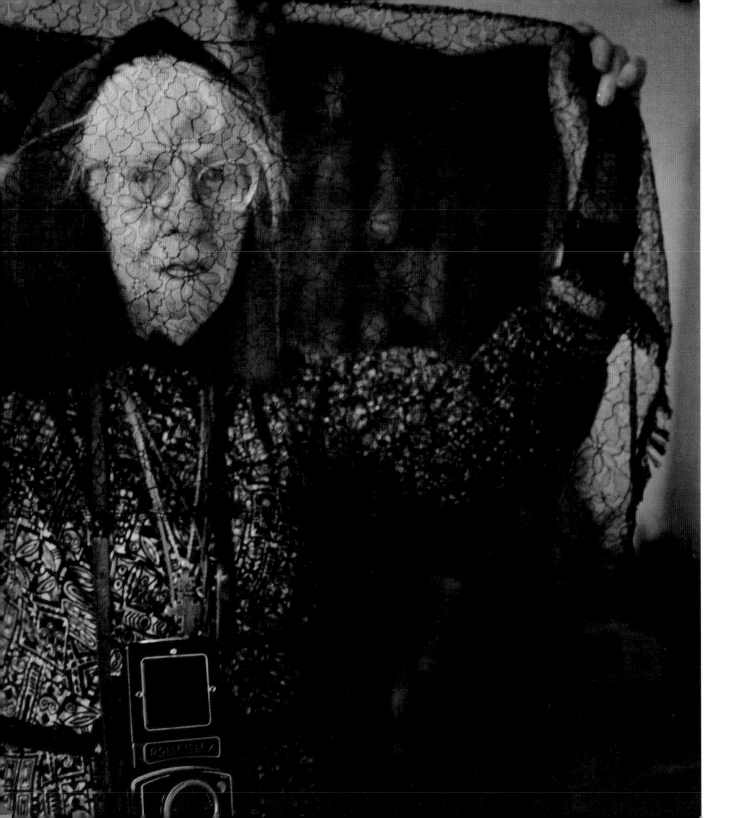

New York

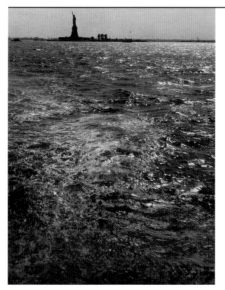

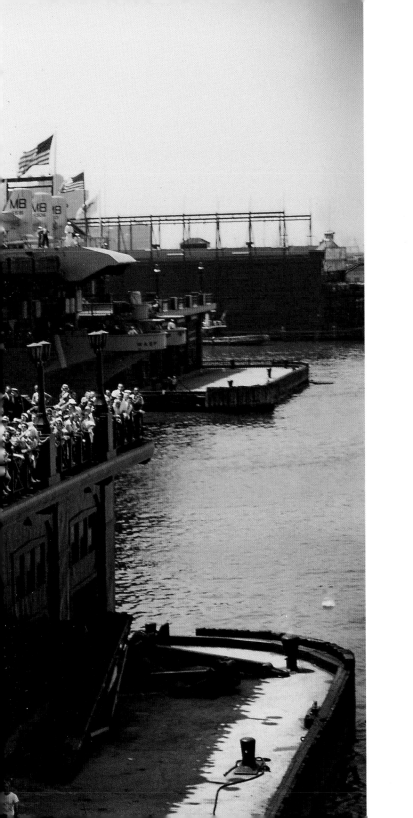

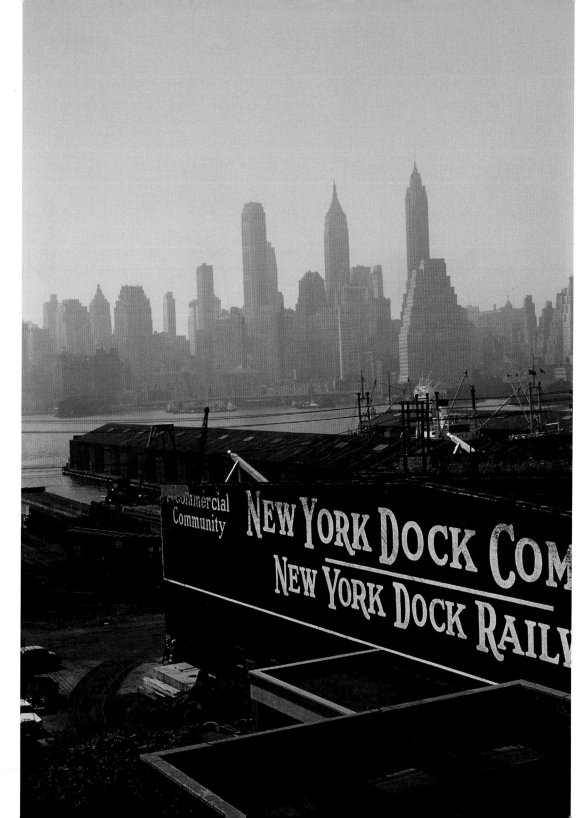

Transatlantic
liner docks

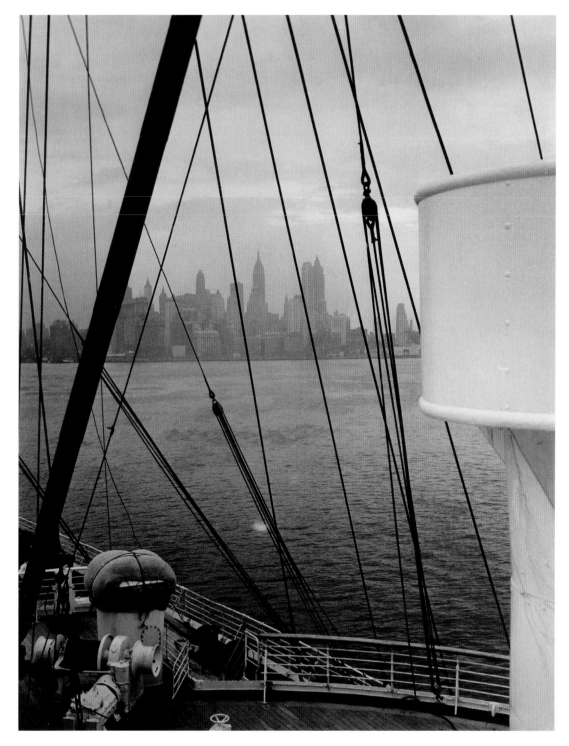

The arrival
of the *Liberté*,
April 8, 1957

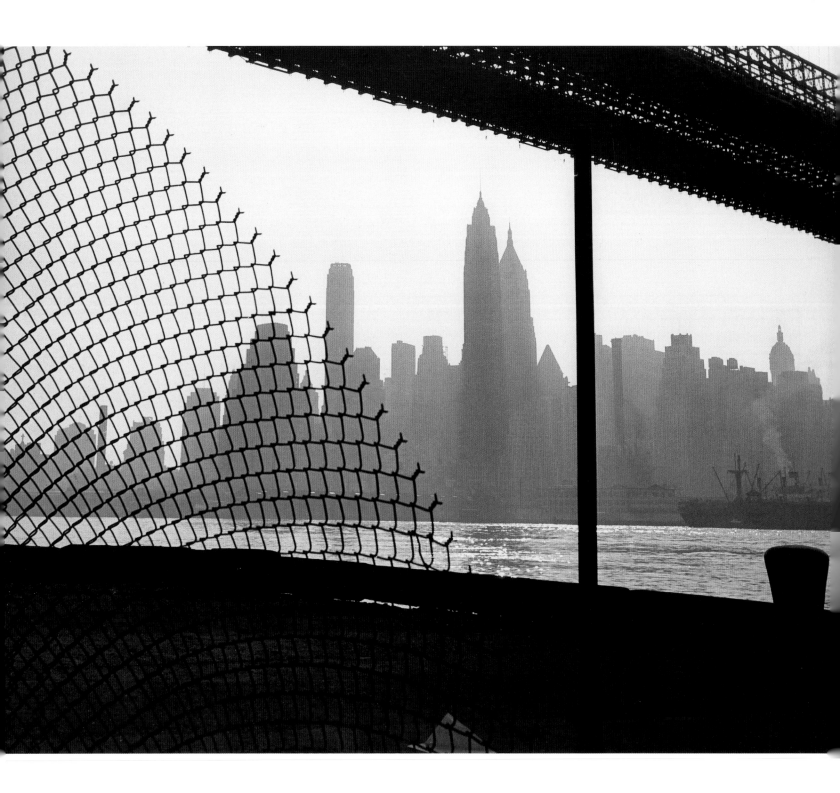

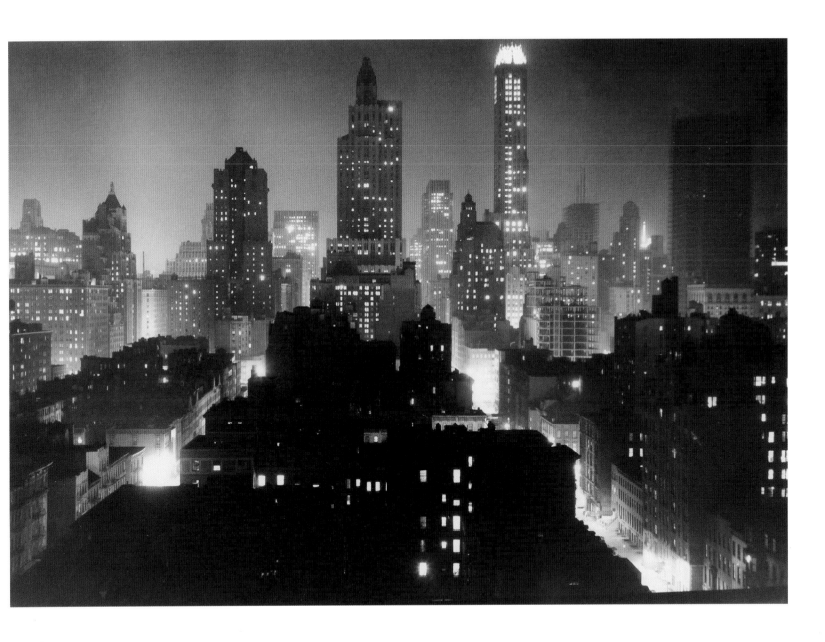

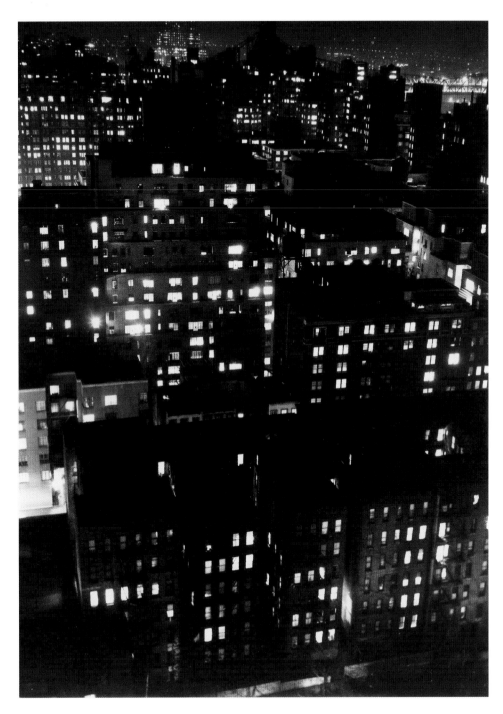

East River

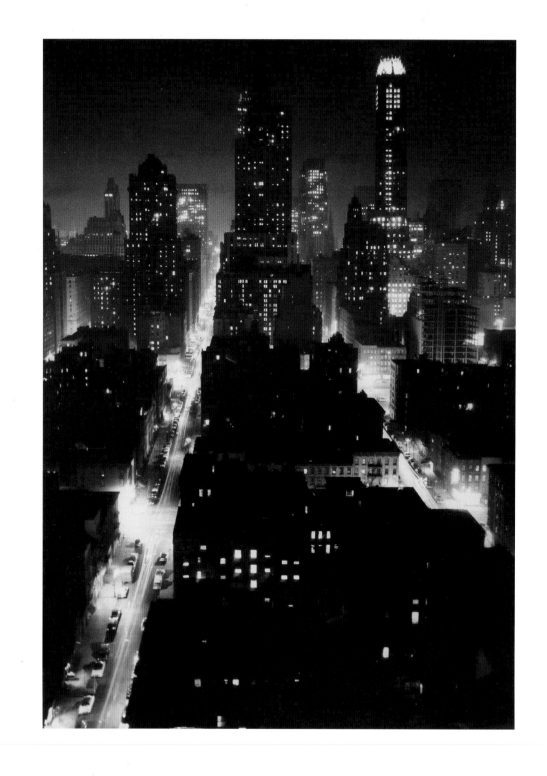

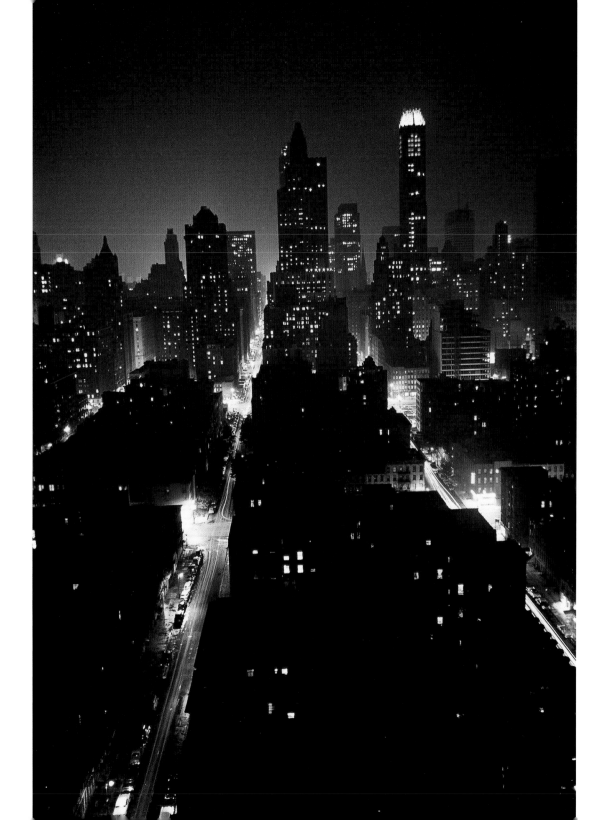

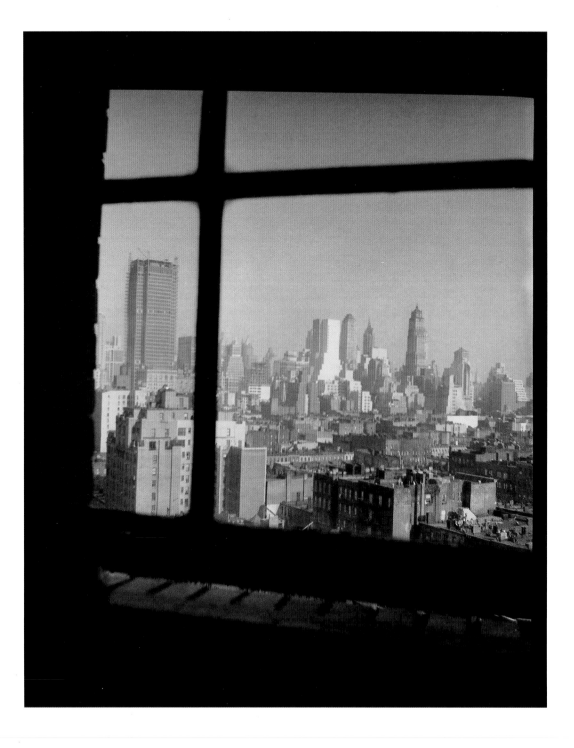

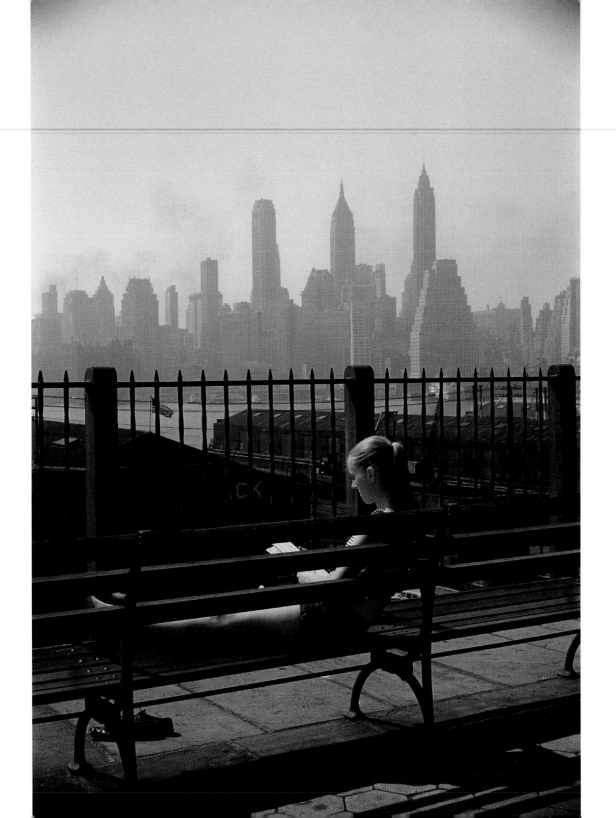

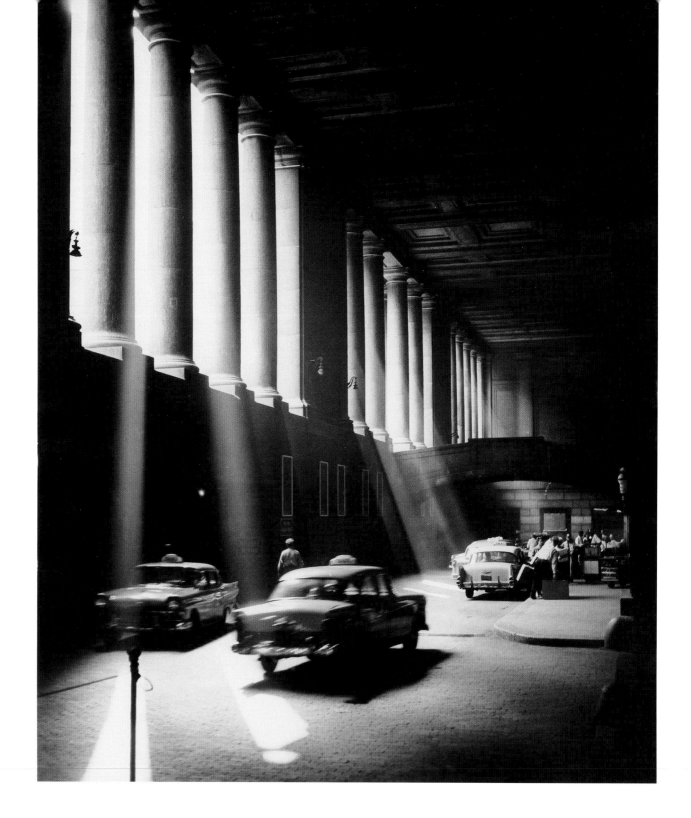

Pennsylvania
Station

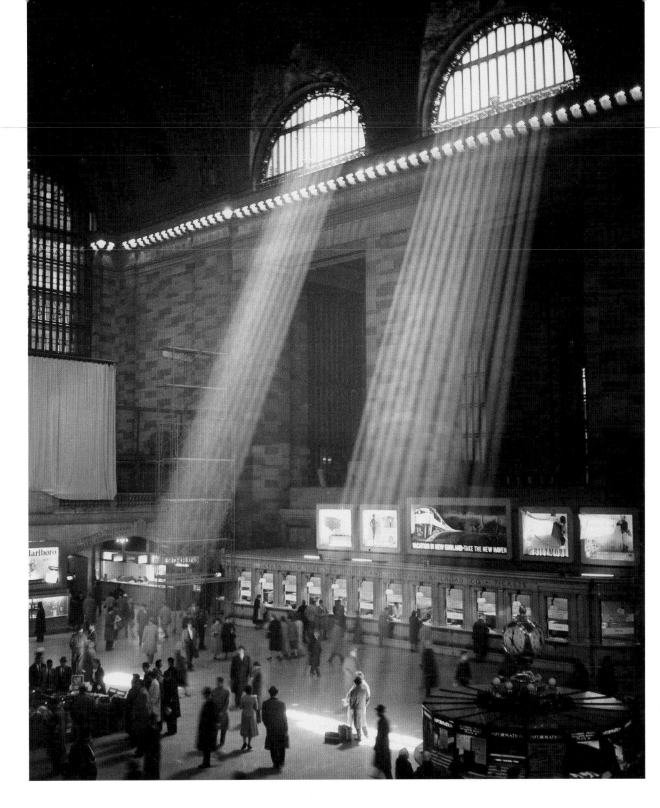

Grand Central
Station

49

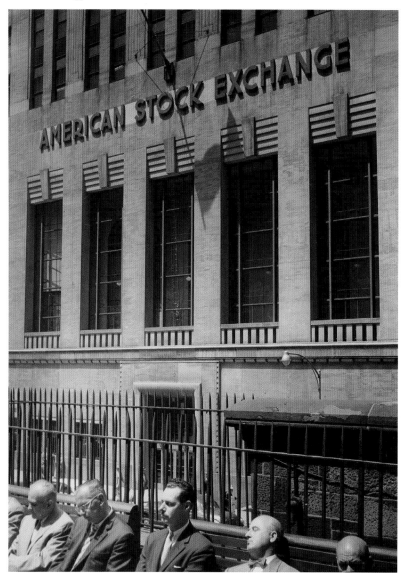

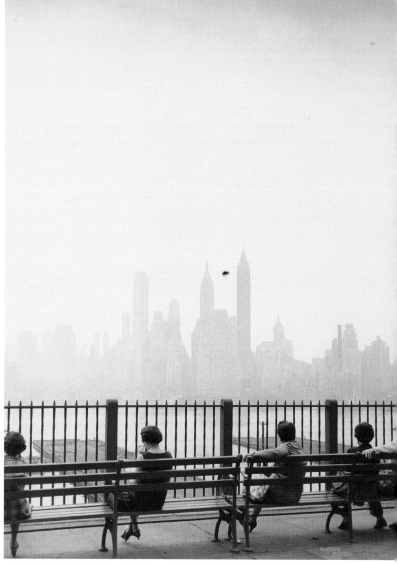

Above: Manhattan seen from Brooklyn
Facing page: Grand Central Station

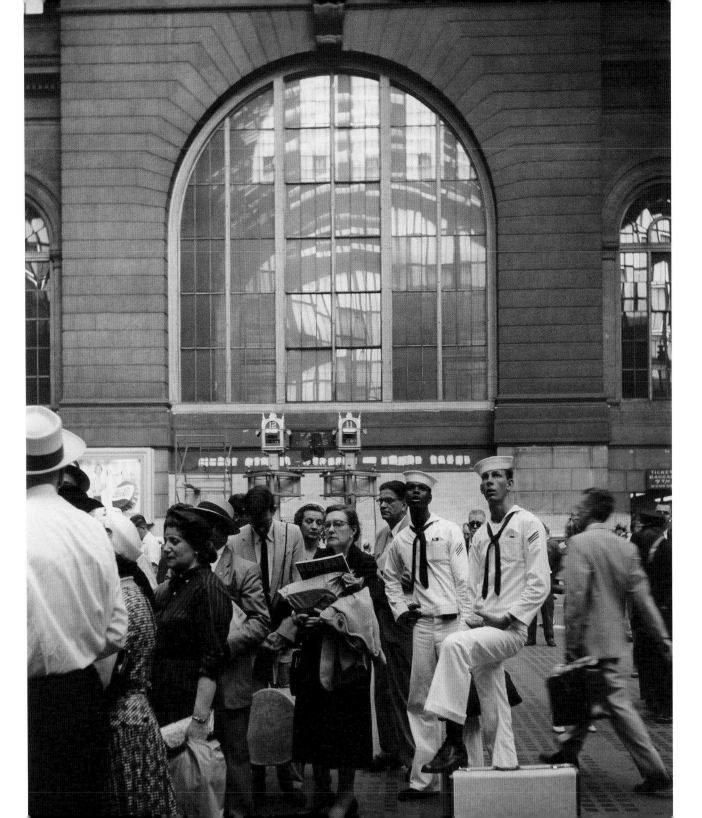

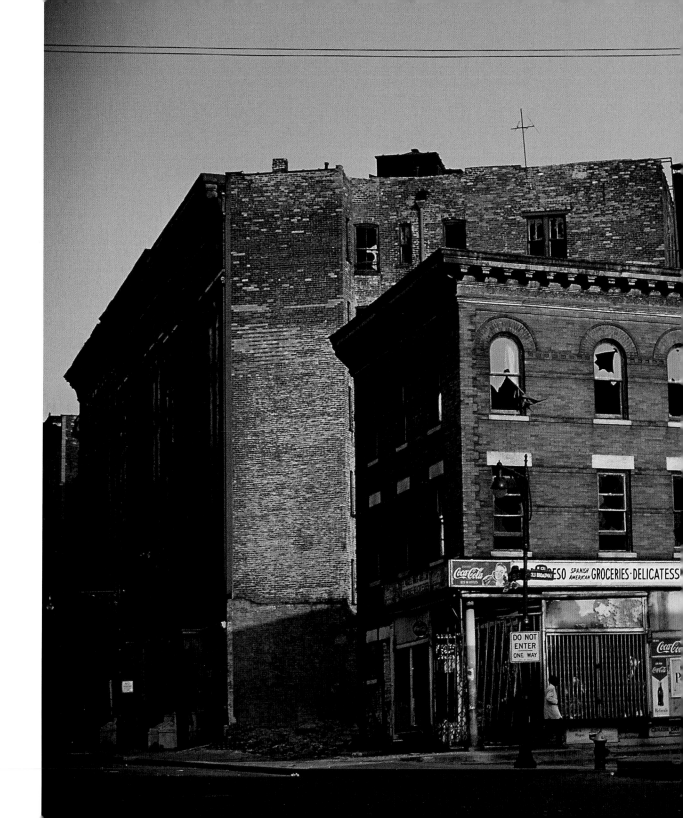

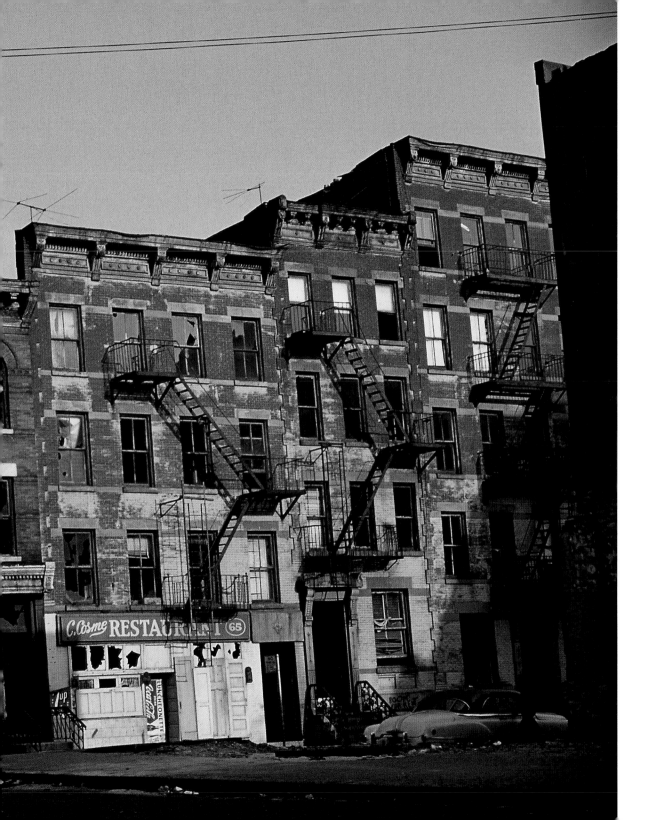

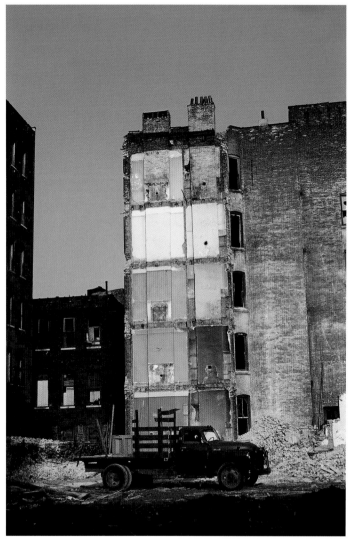

Greenwich Village

Manhattan

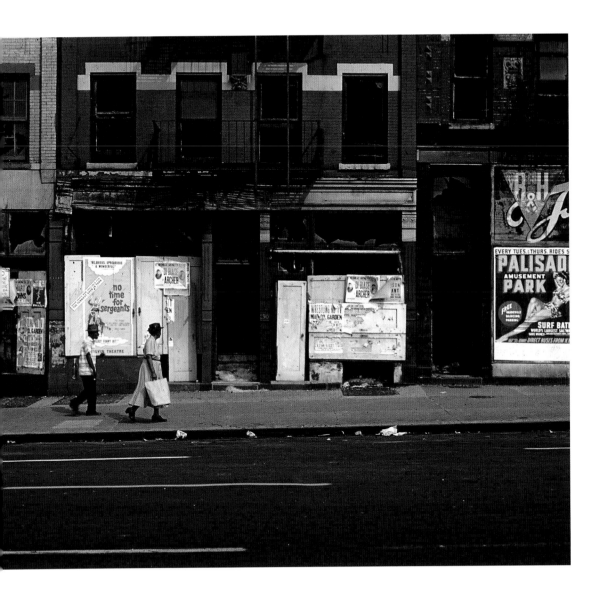

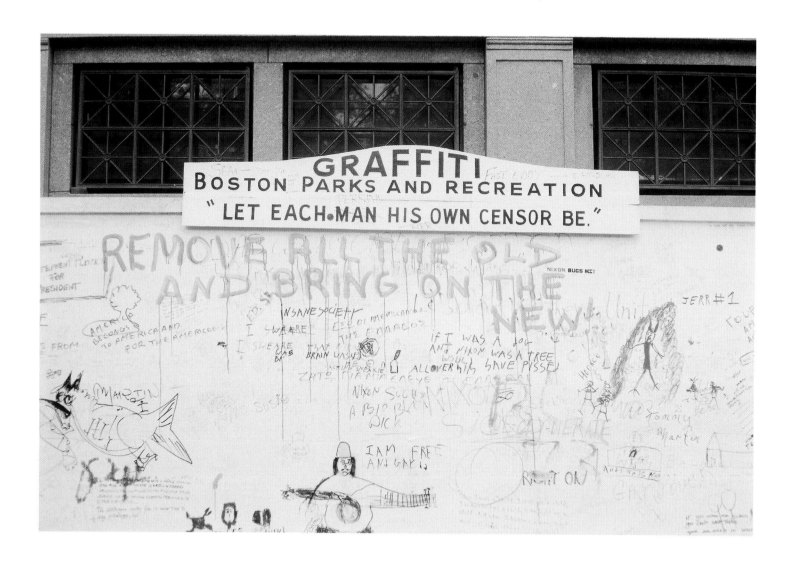

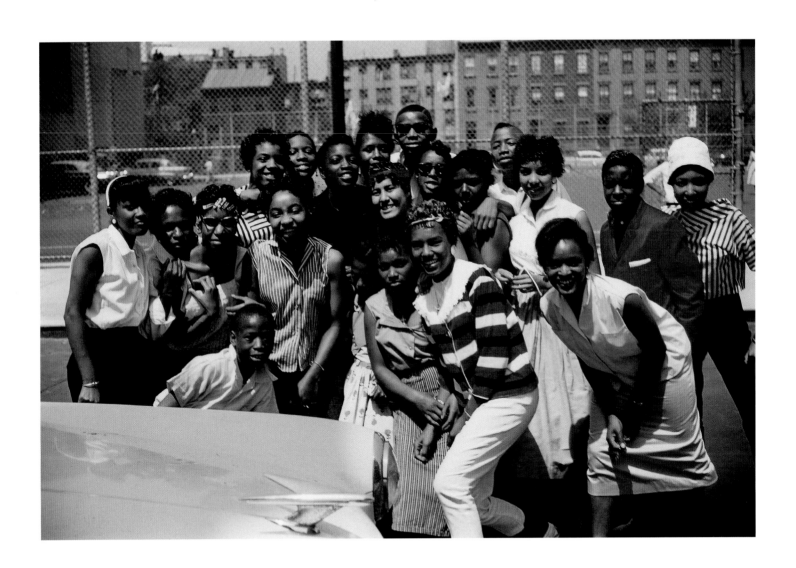

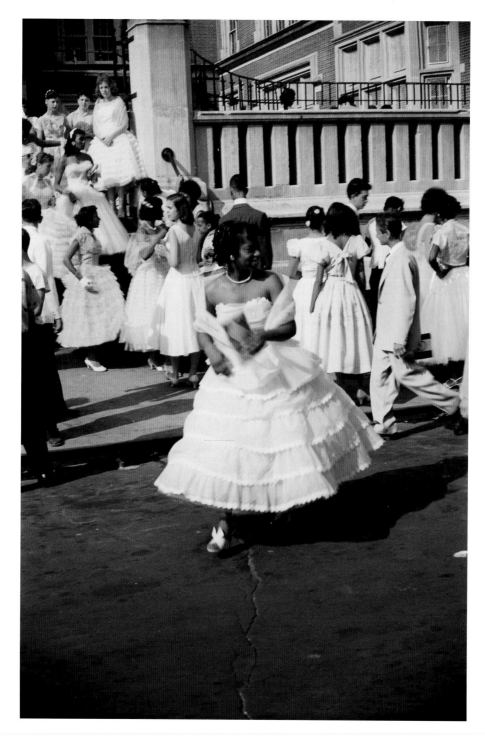

Left and facing page:
Brooklyn

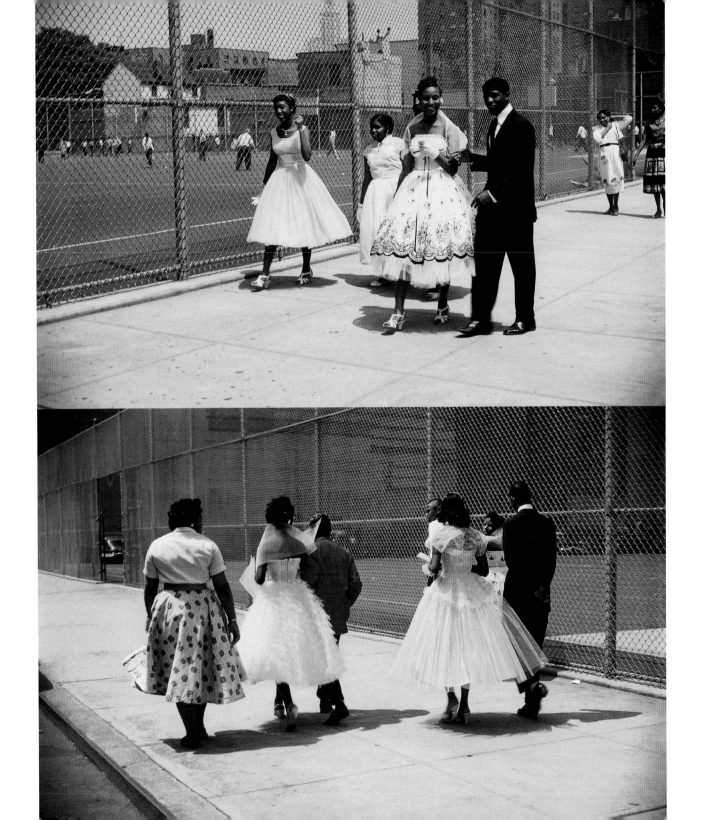

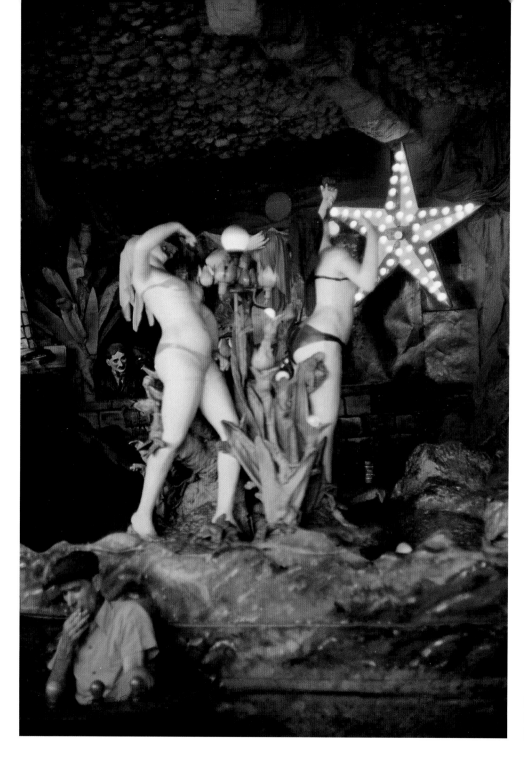

Left, facing page, and
following double page:
Coney Island

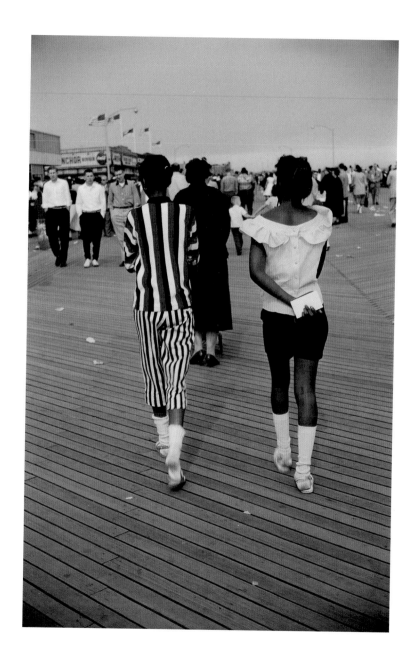

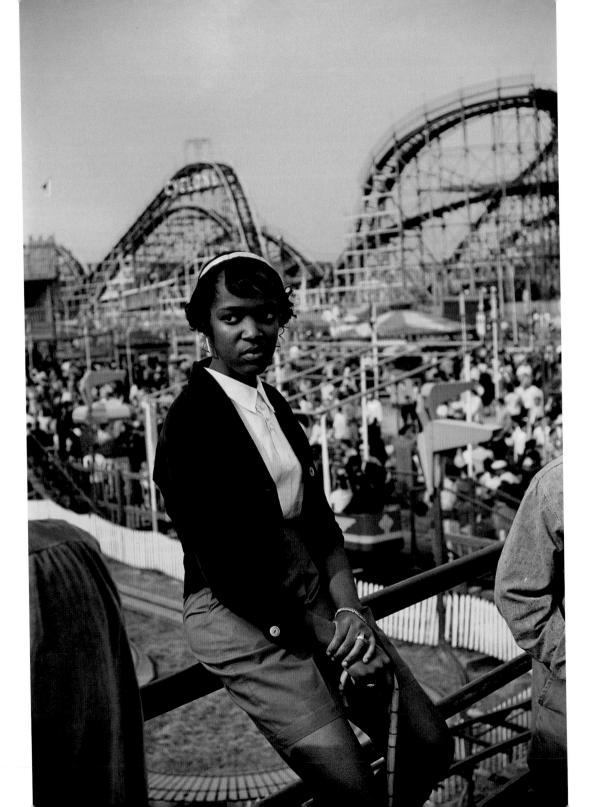

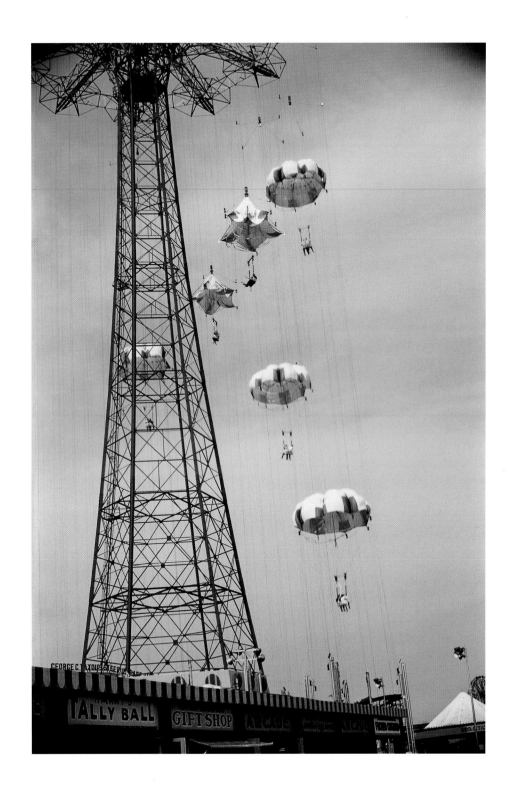

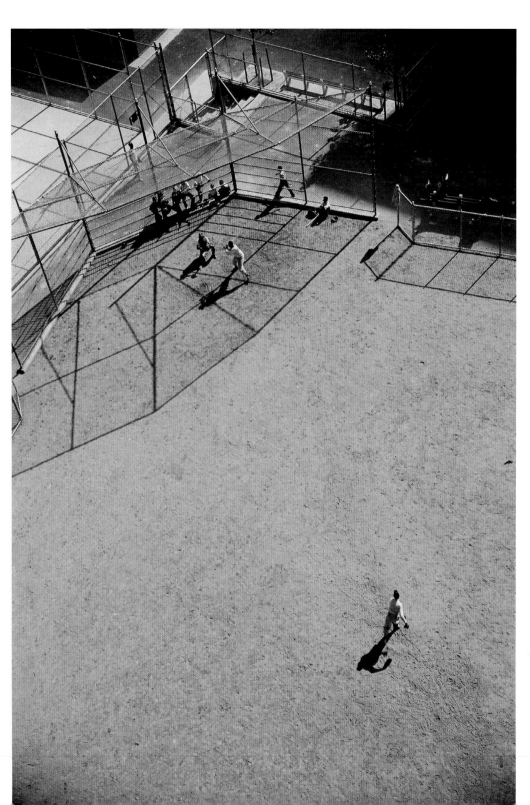

Left and facing page:
Brooklyn

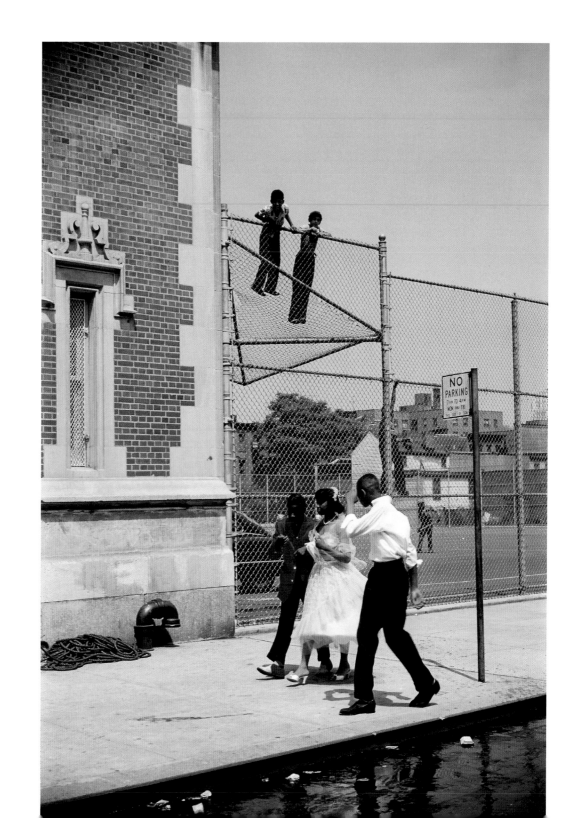

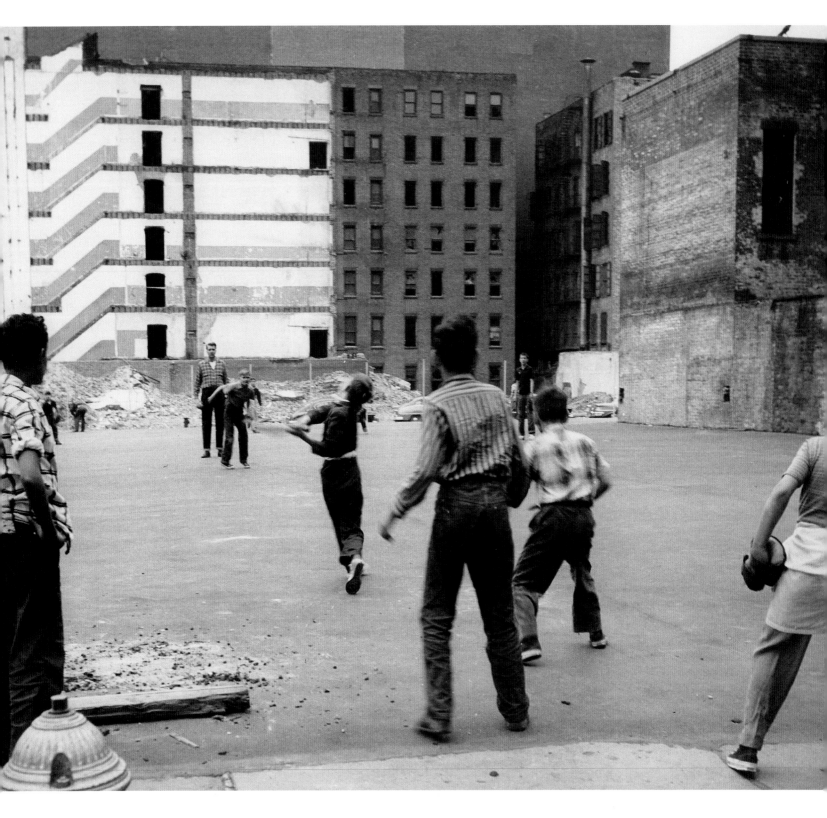

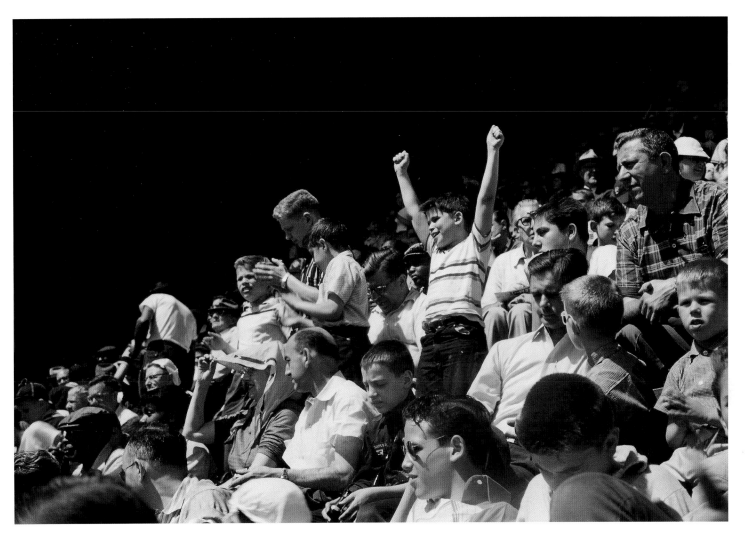

Facing page: Greenwich Village

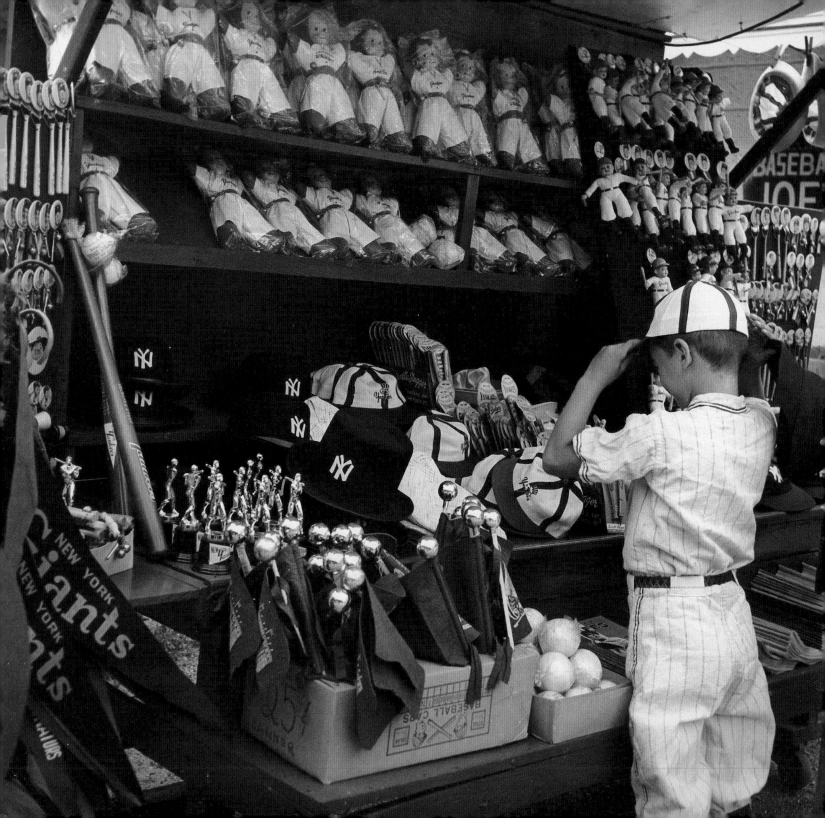

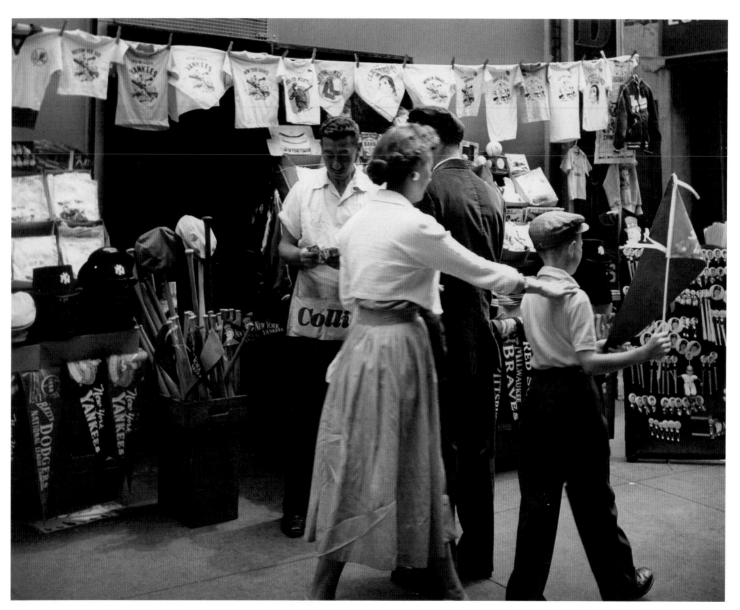

Facing page and above: Yankee Stadium

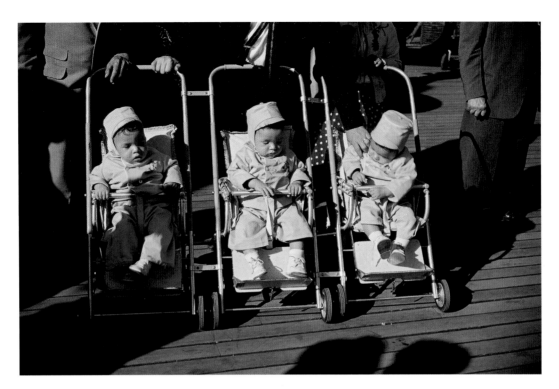

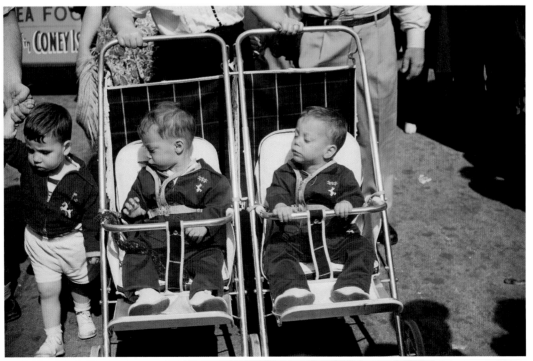

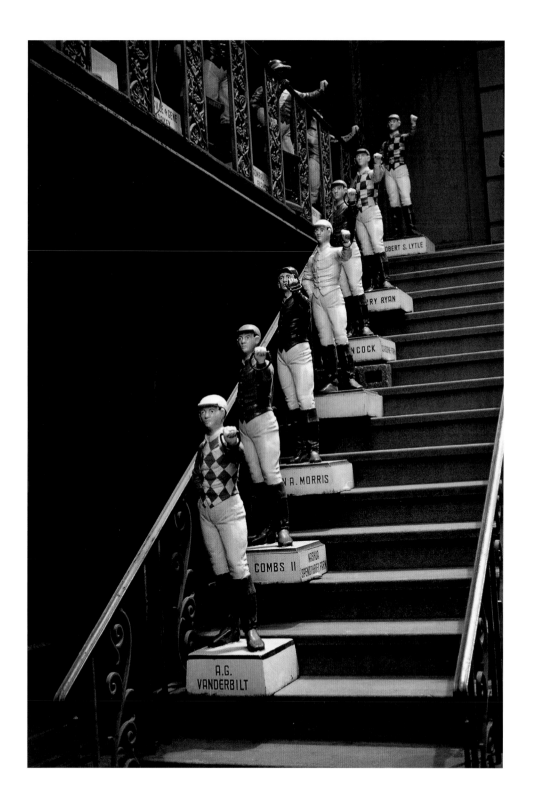

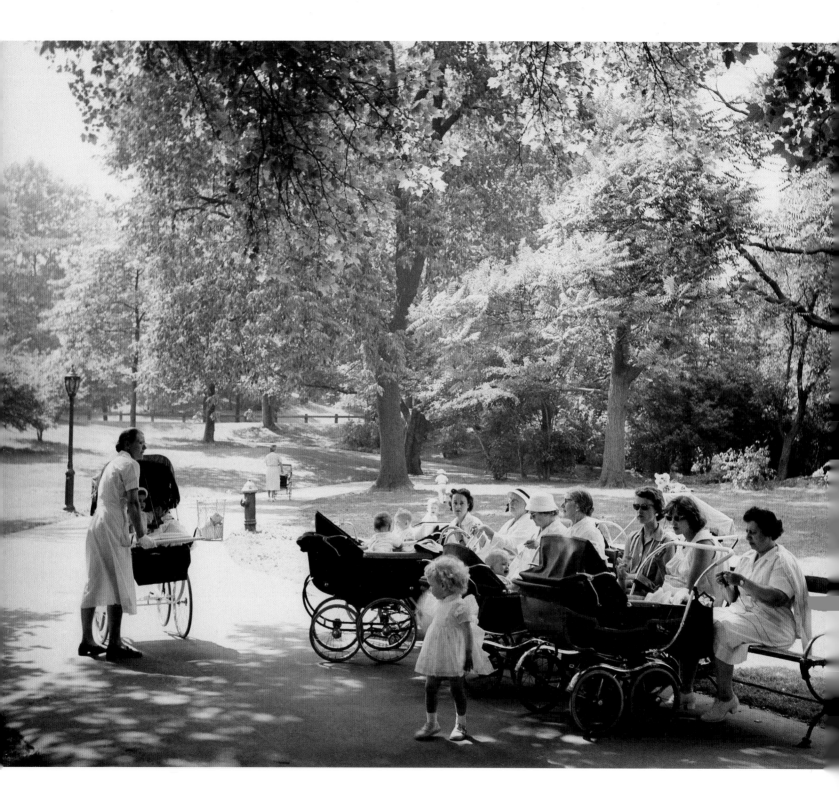

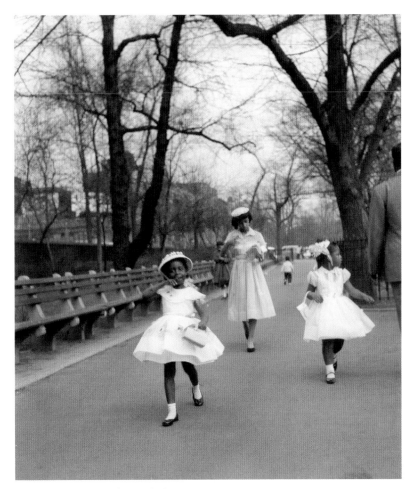

Facing page and above: Central Park

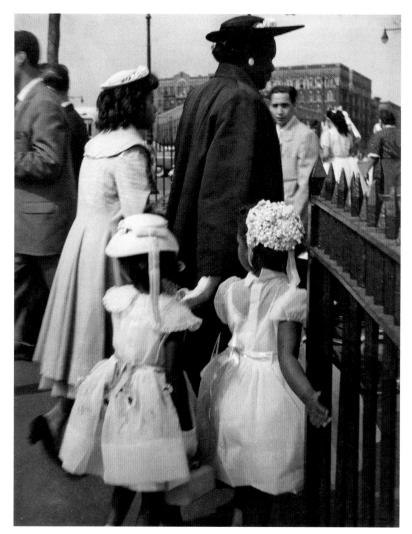

Harlem

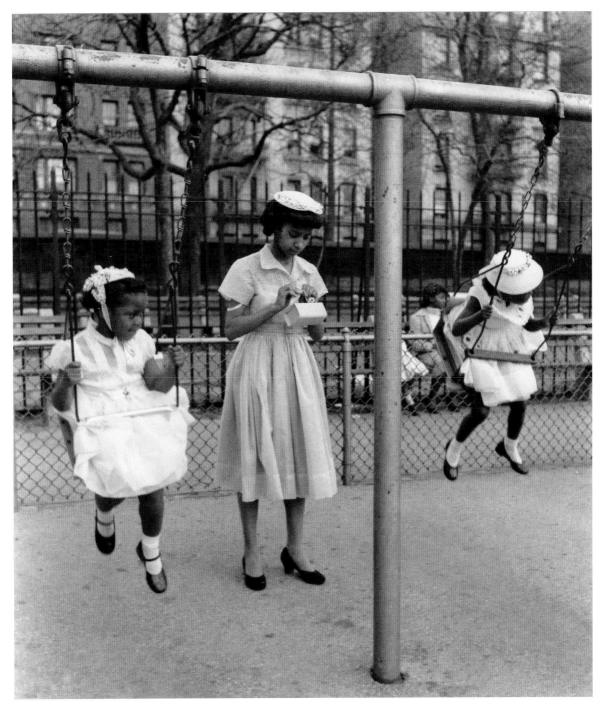

Central Park

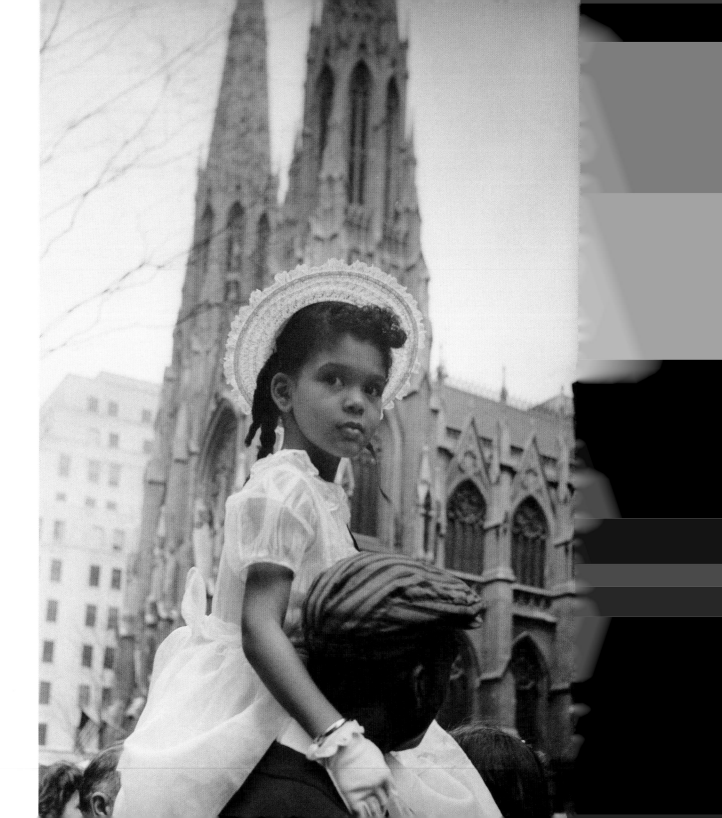

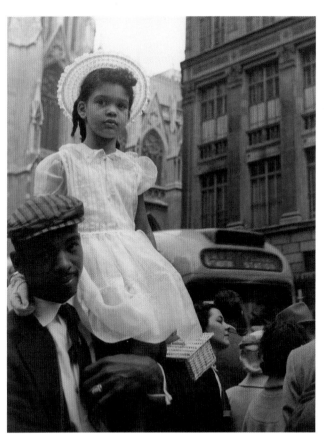

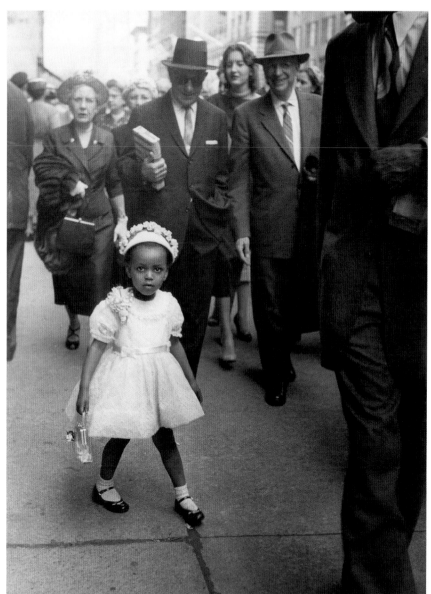

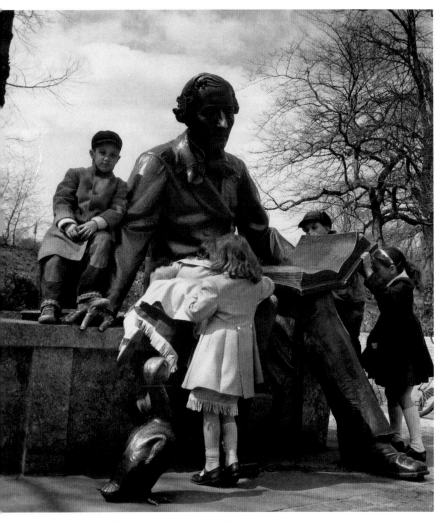
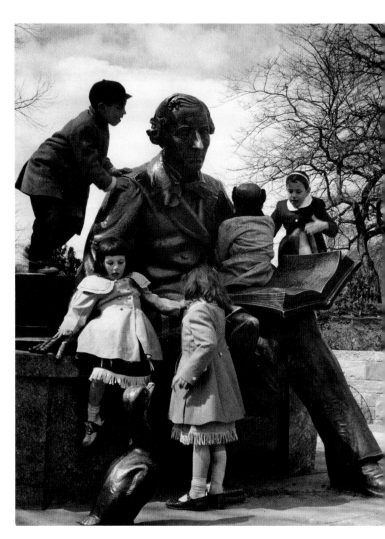

Statue of Hans Christian Andersen, Central Park

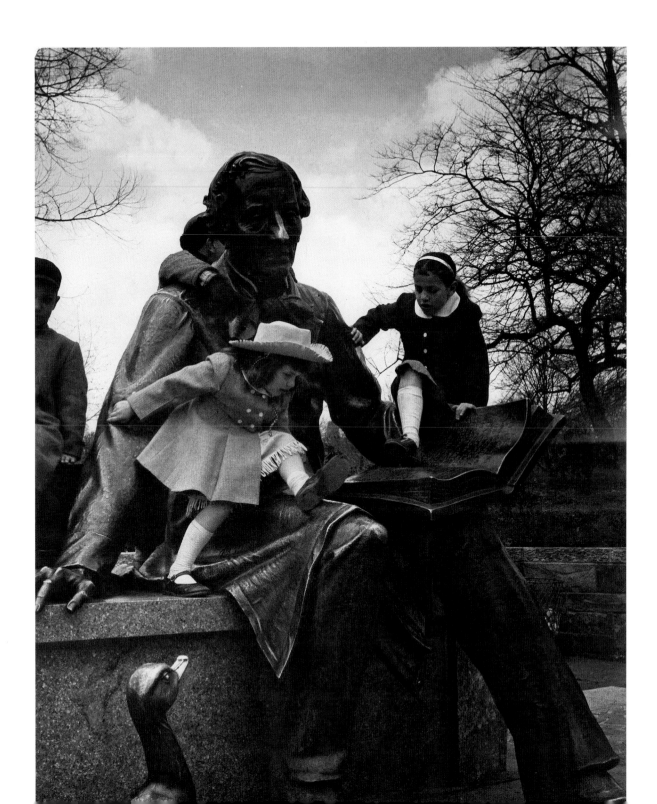

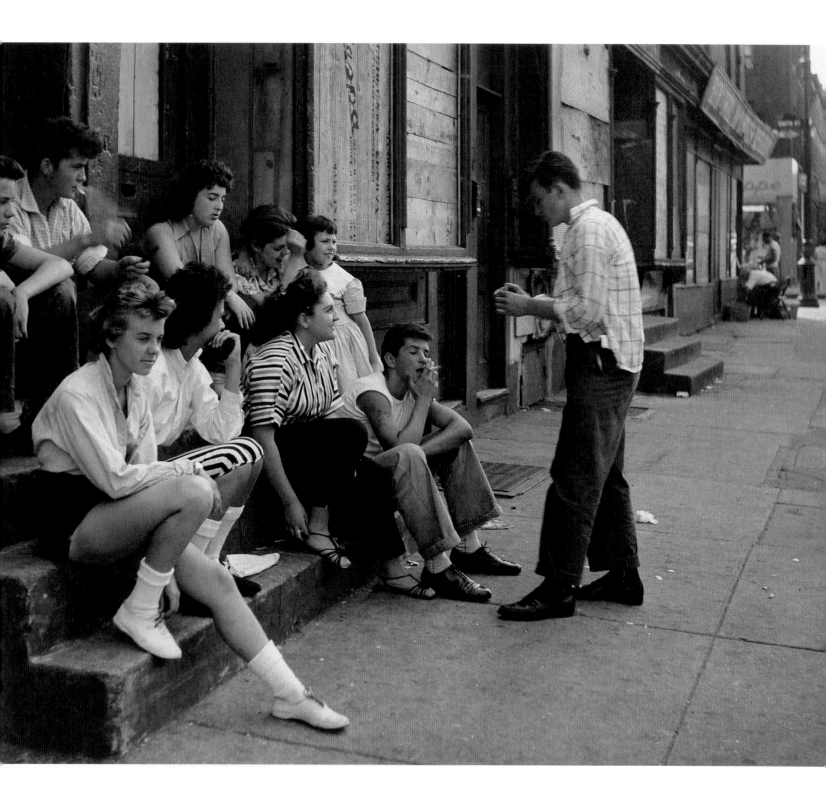

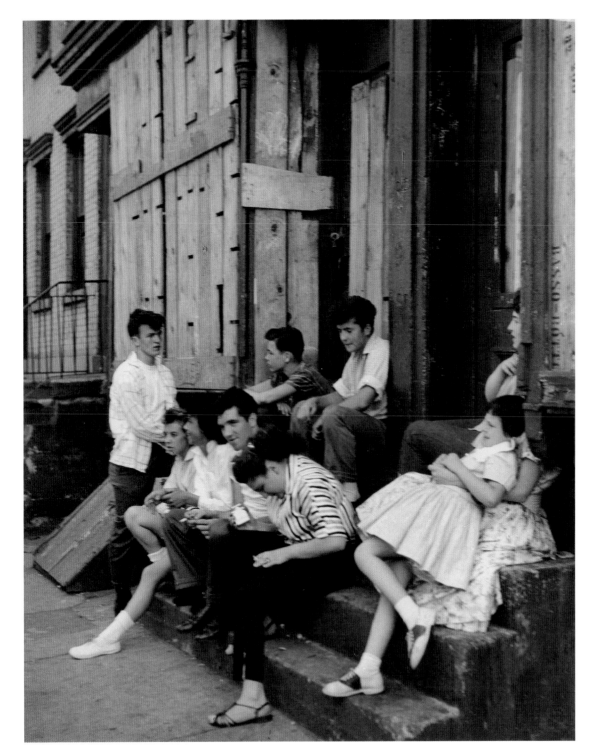

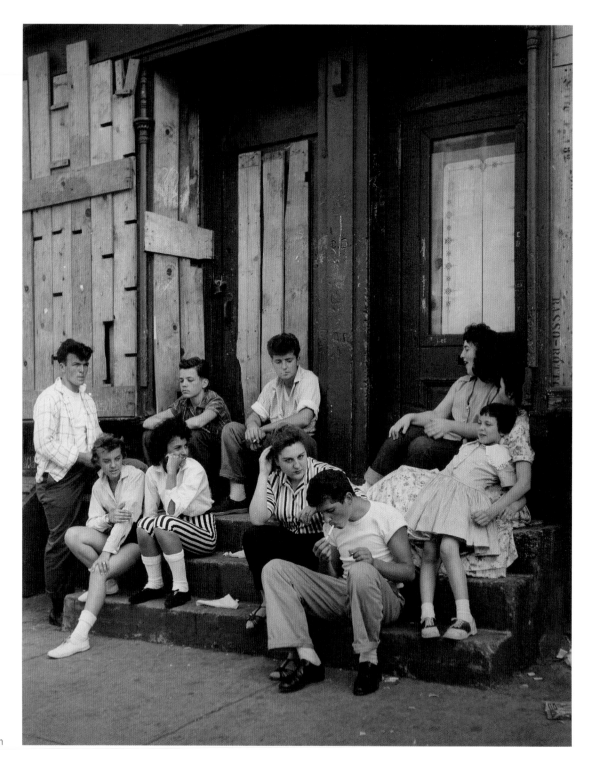

Brooklyn

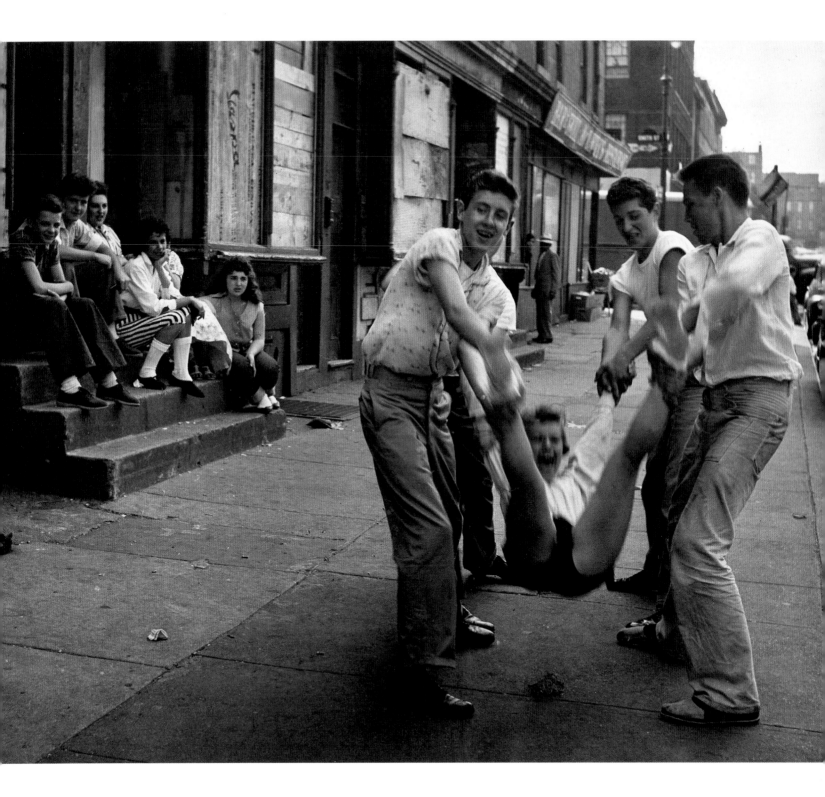

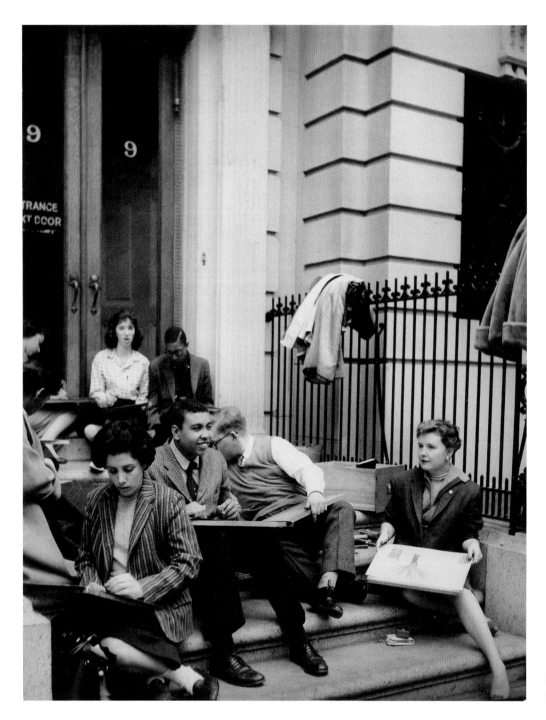

Left: Art school
Facing page: The Bowery

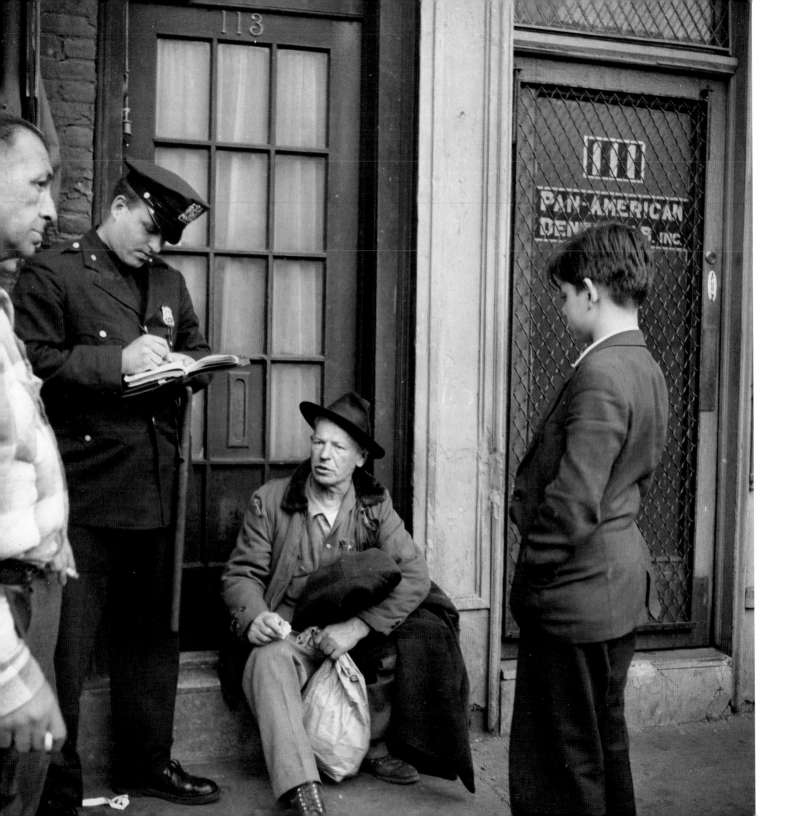

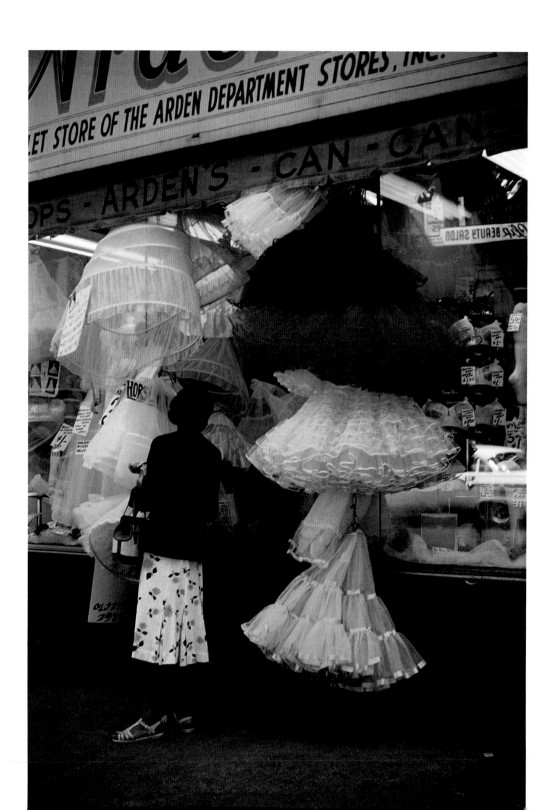

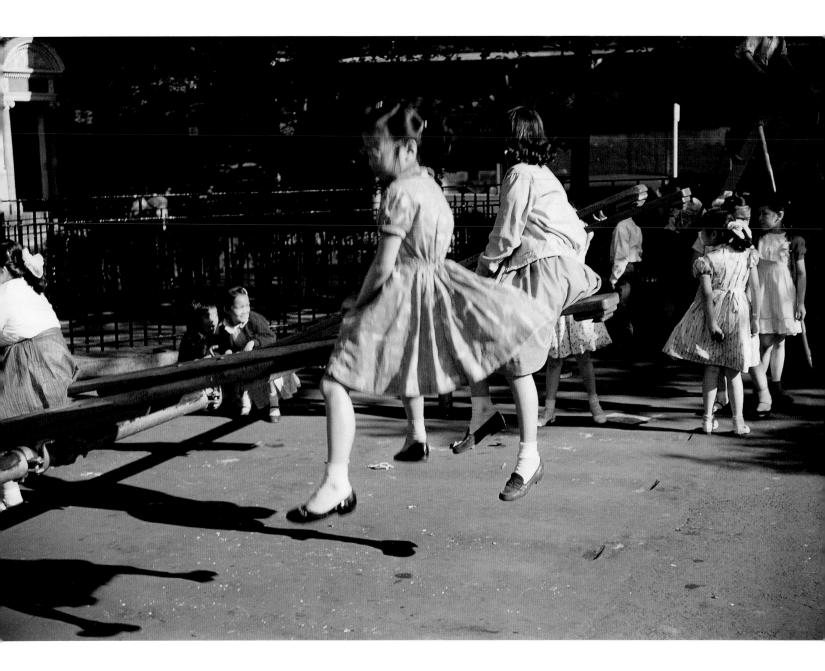

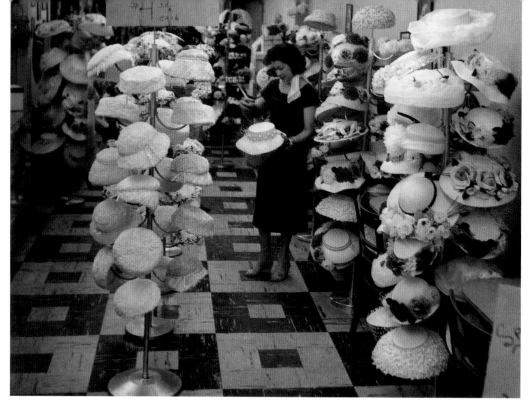

Seventh Avenue

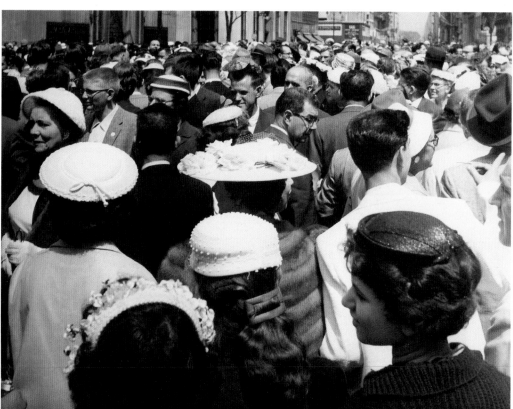

Easter Parade,
Fifth Avenue

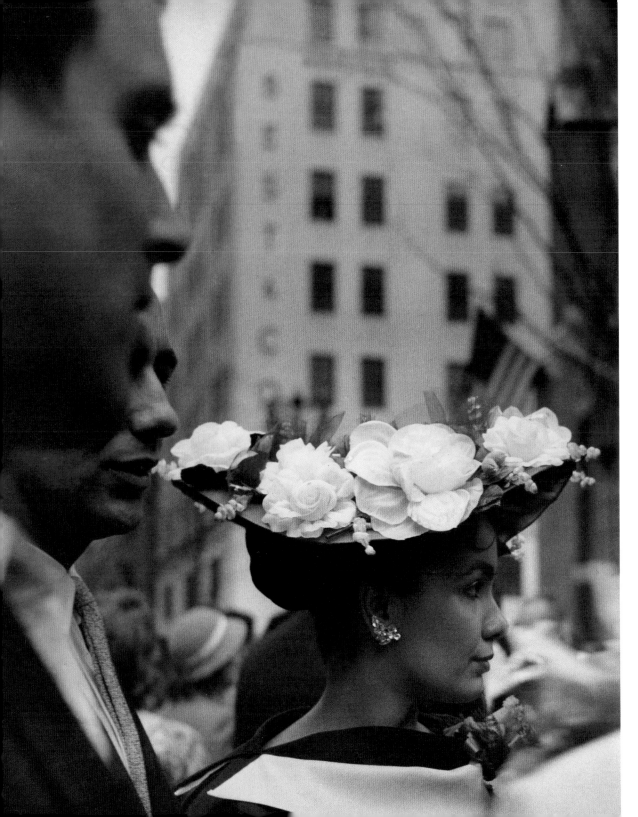

Easter Parade,
Fifth Avenue

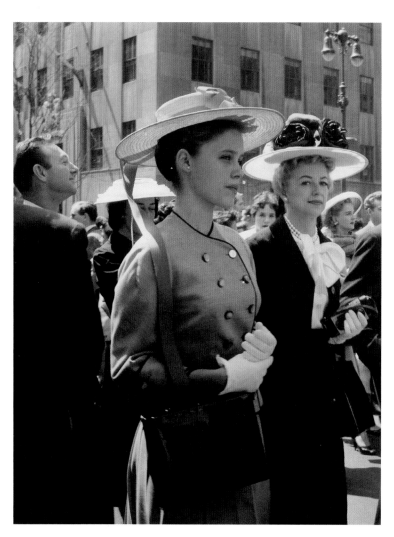
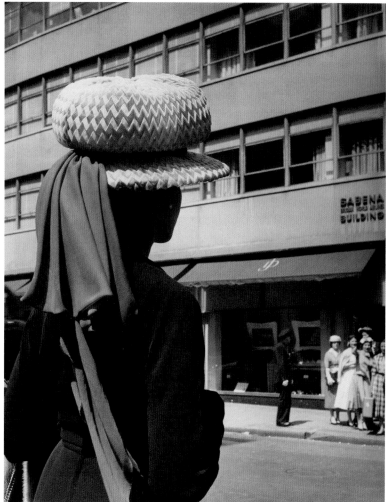

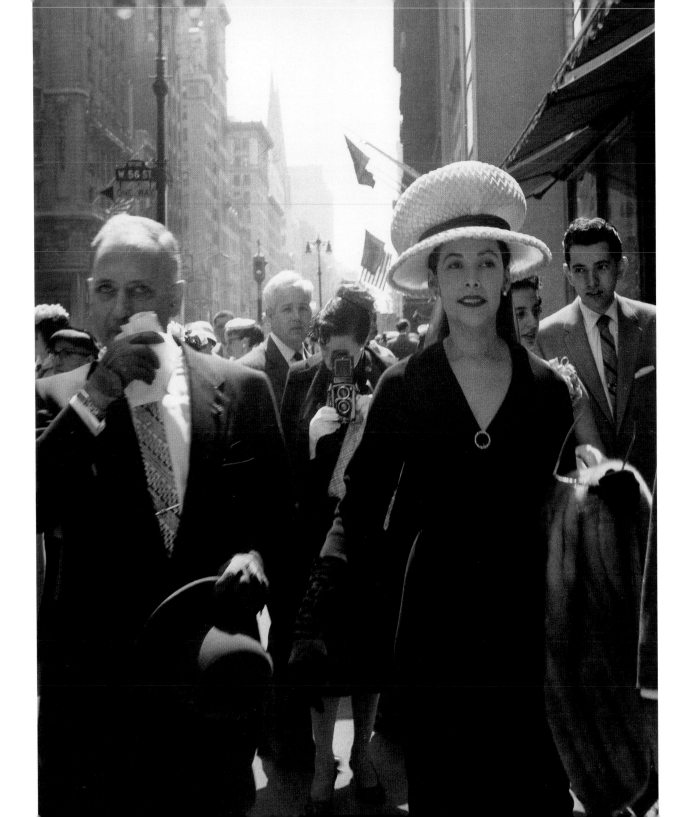

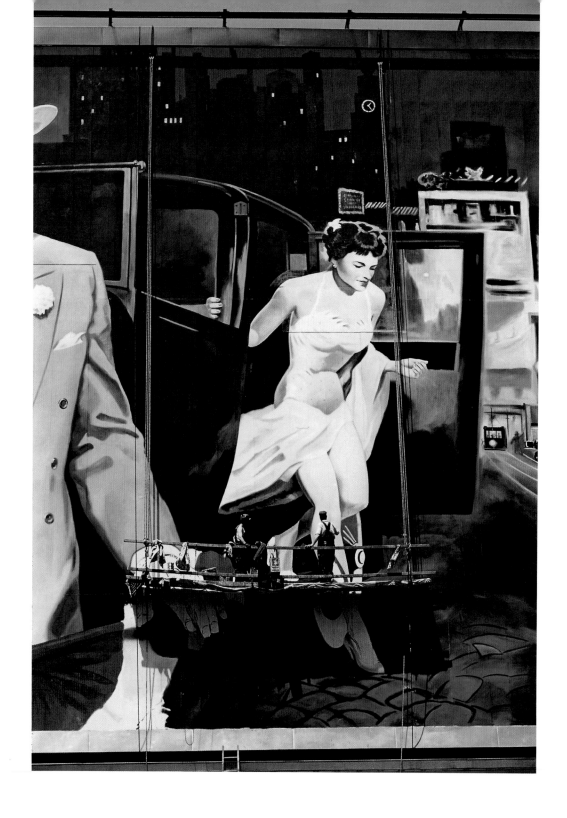

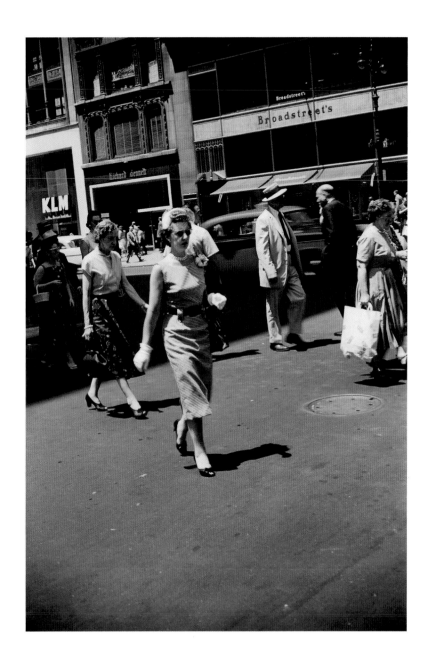

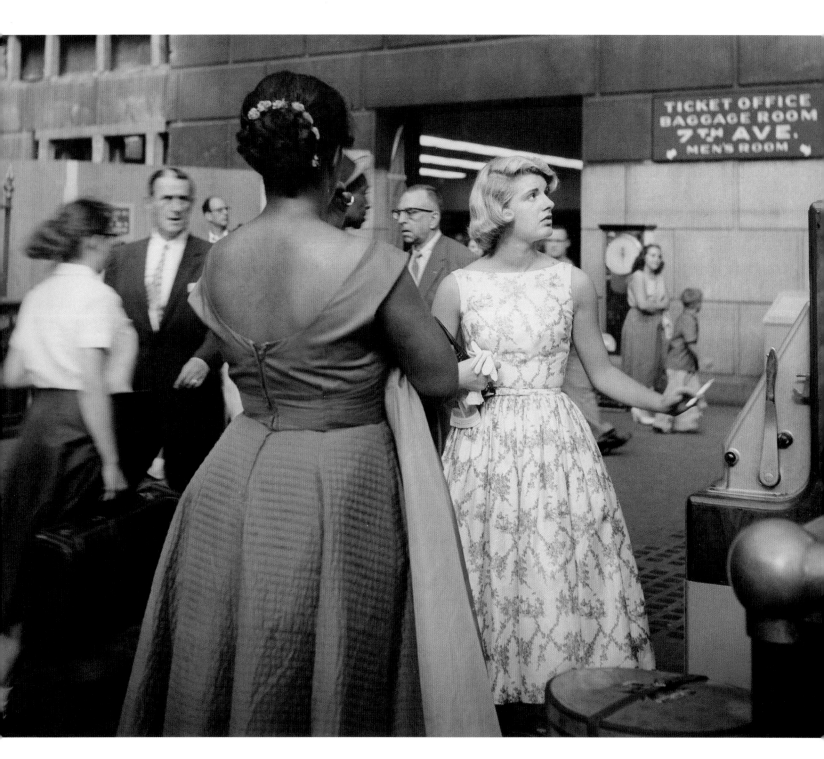

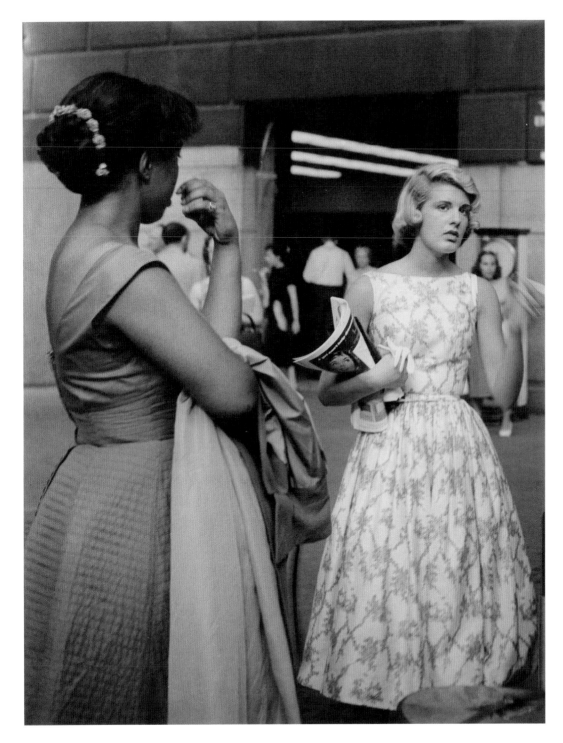

Fifth Avenue

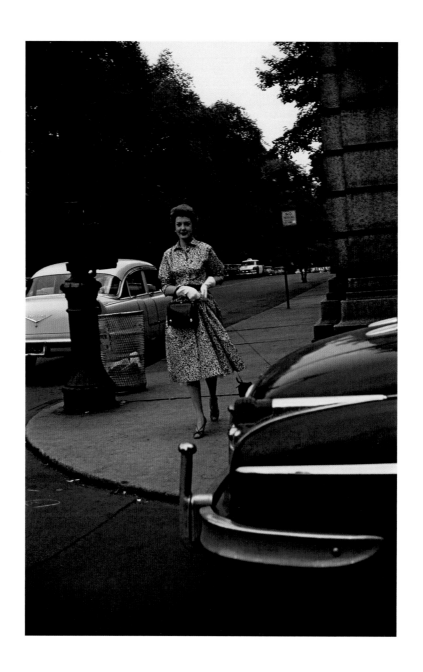

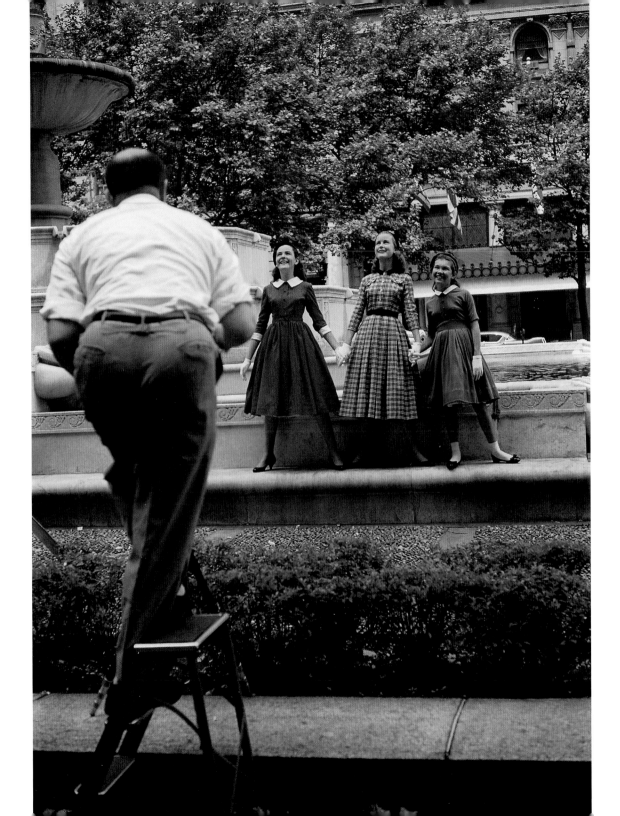

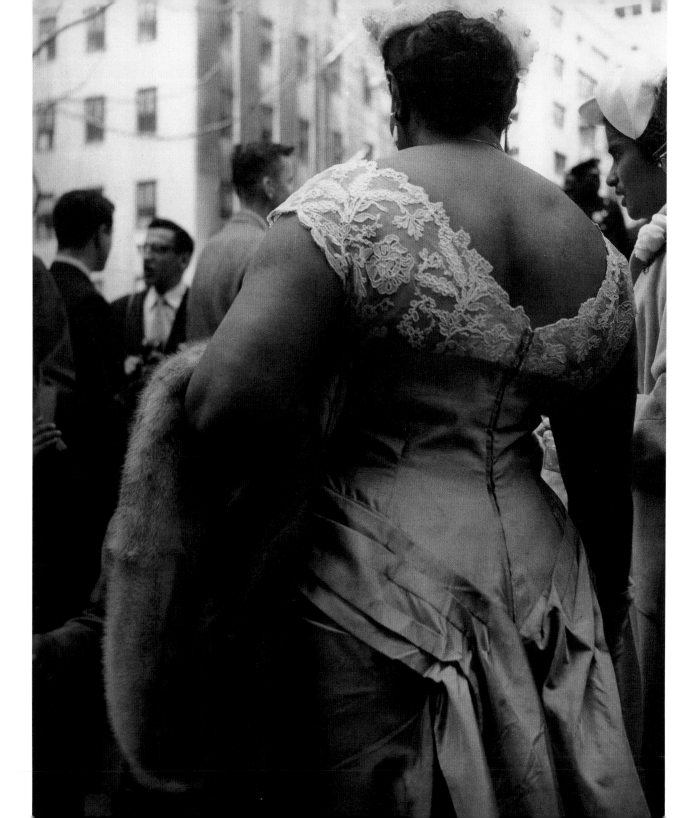

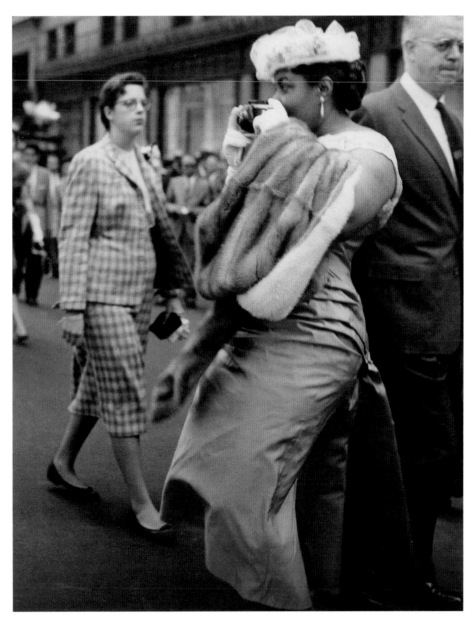

Facing page and above: Easter Parade

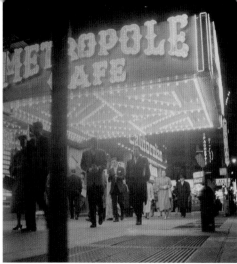

The Metropole Café, Broadway

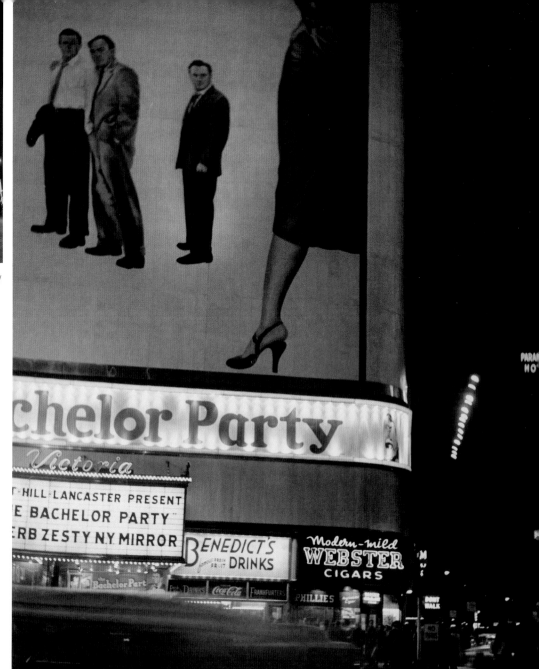

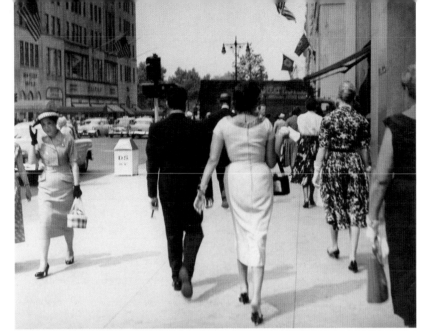

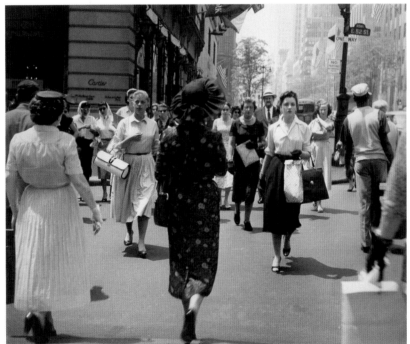

Fifth Avenue

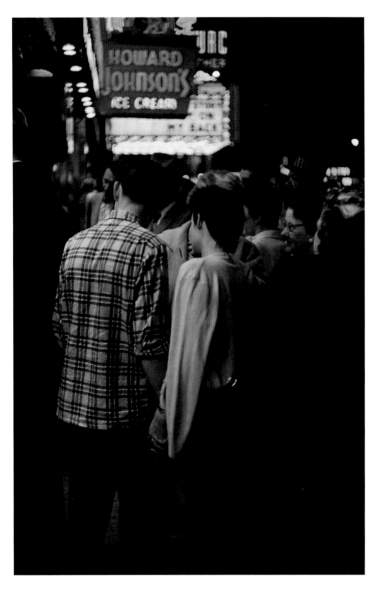
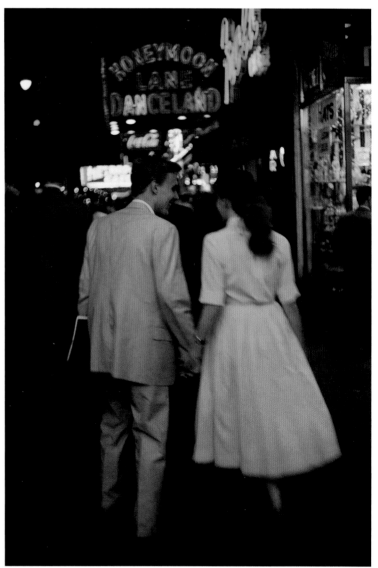

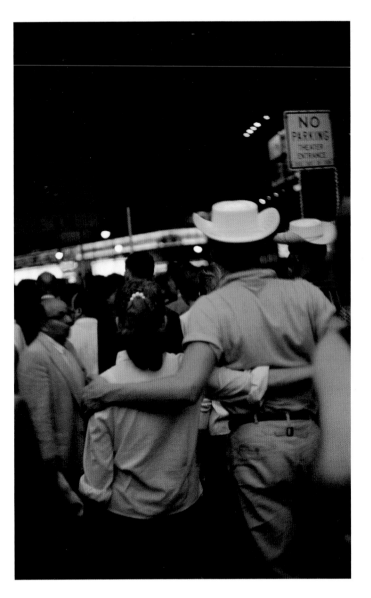

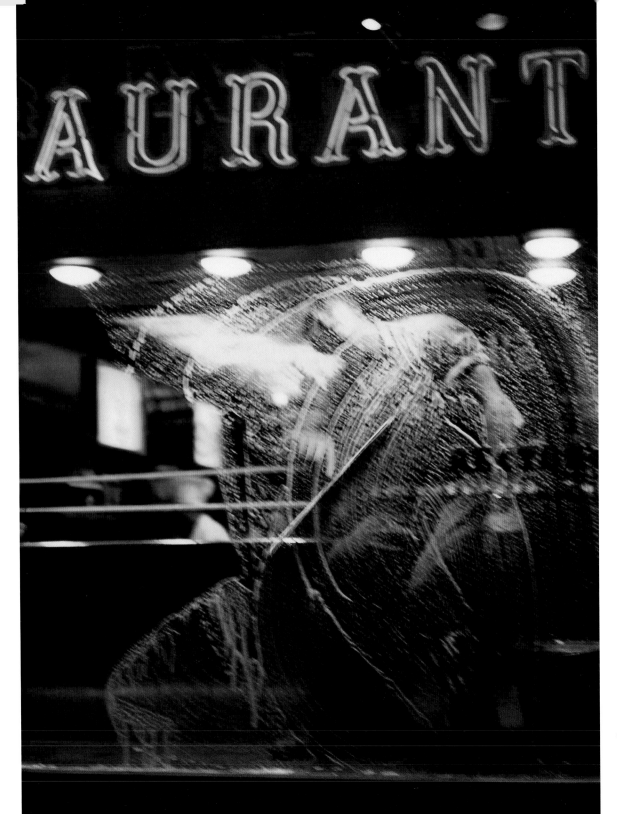

At night

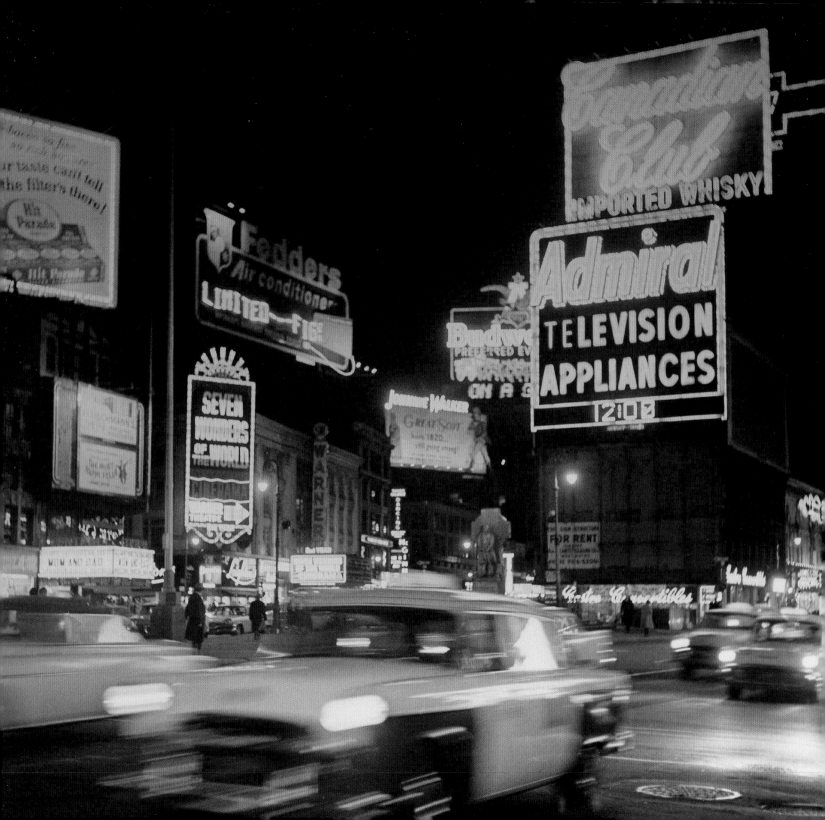

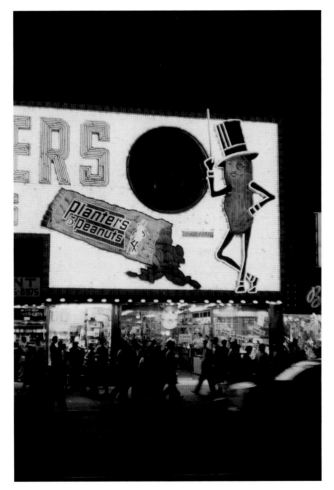

Facing page: Times Square

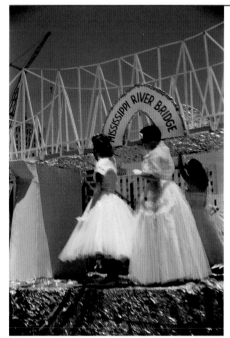

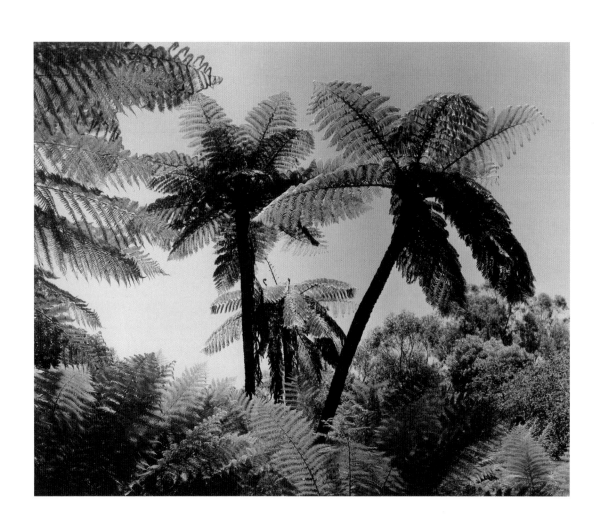

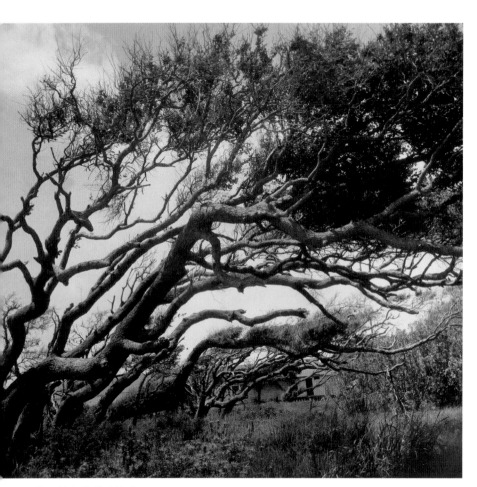

Grand Isle, Gulf of Mexico

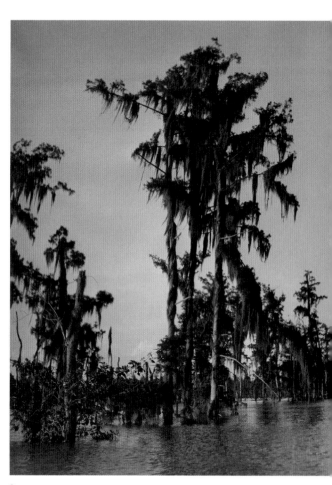

Bayou

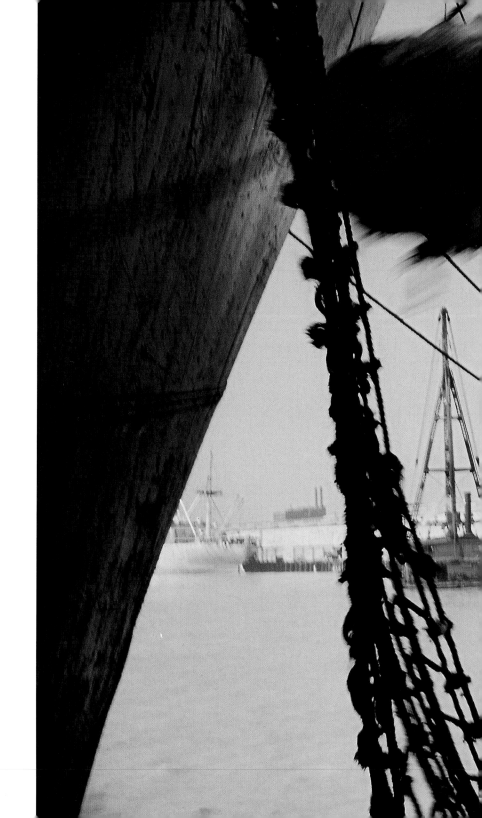

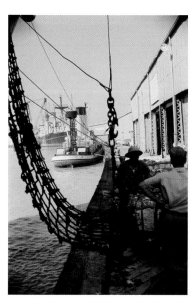

New Orleans, Mississippi River

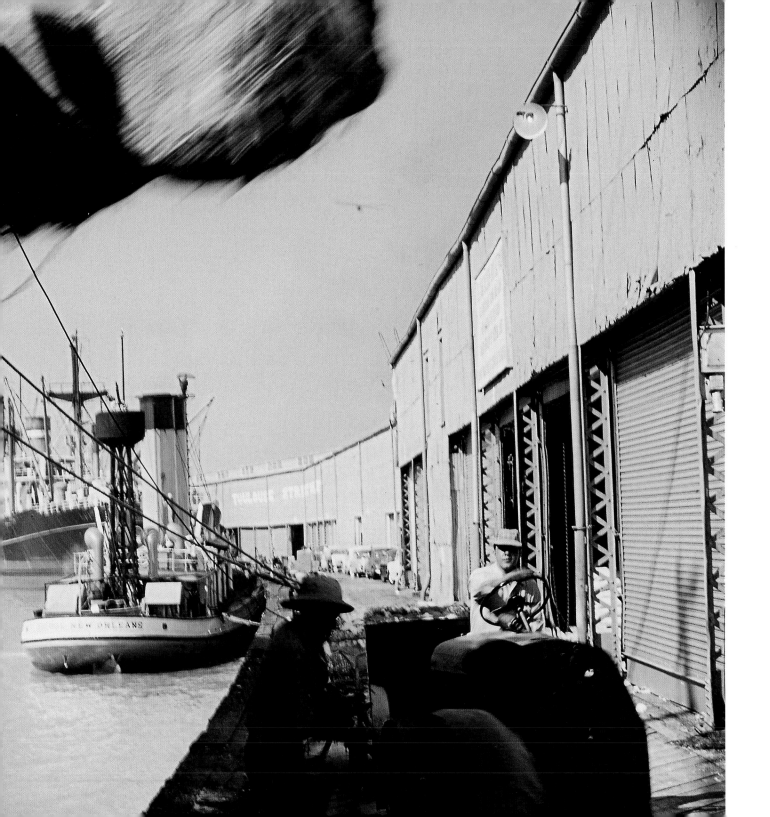

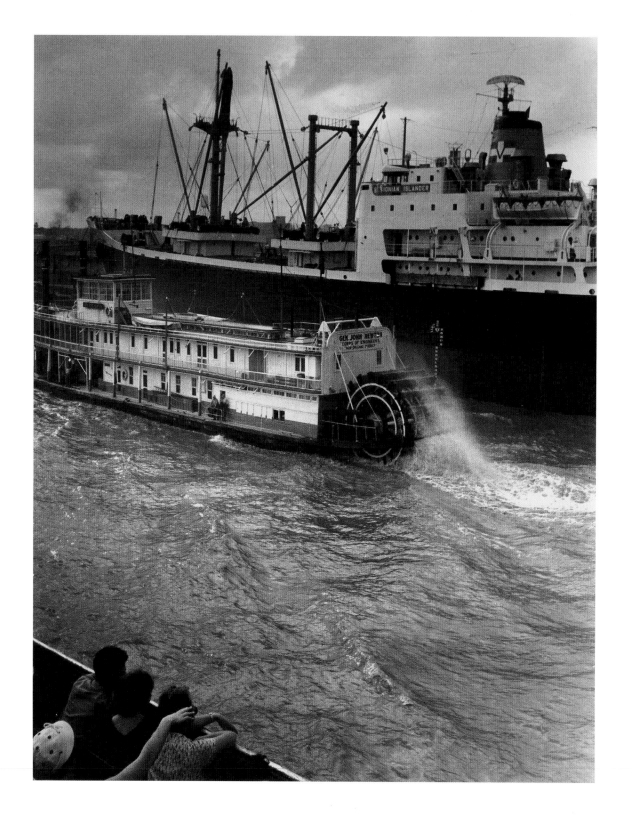

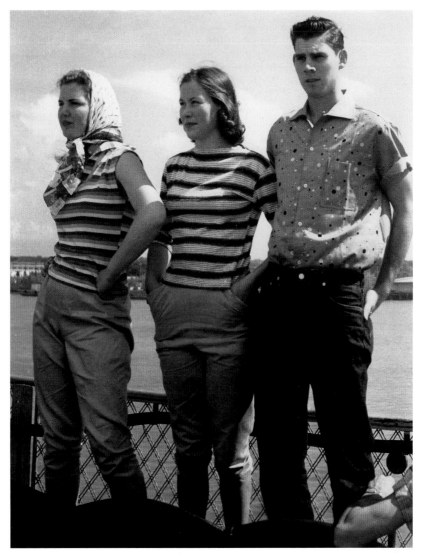

Above: On the Mississippi, New Orleans
Facing page: The last paddle steamer on the Mississippi

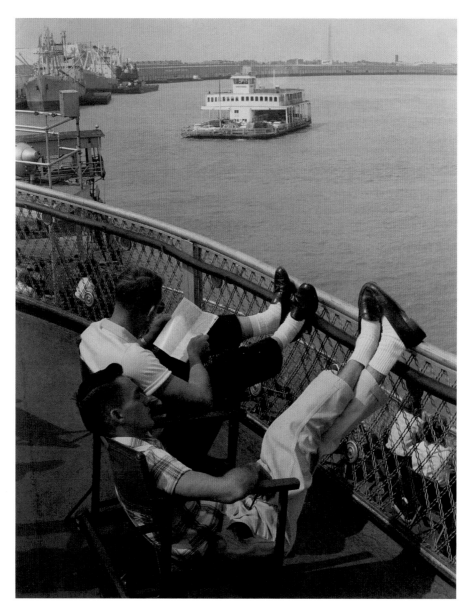

On the Mississippi, New Orleans

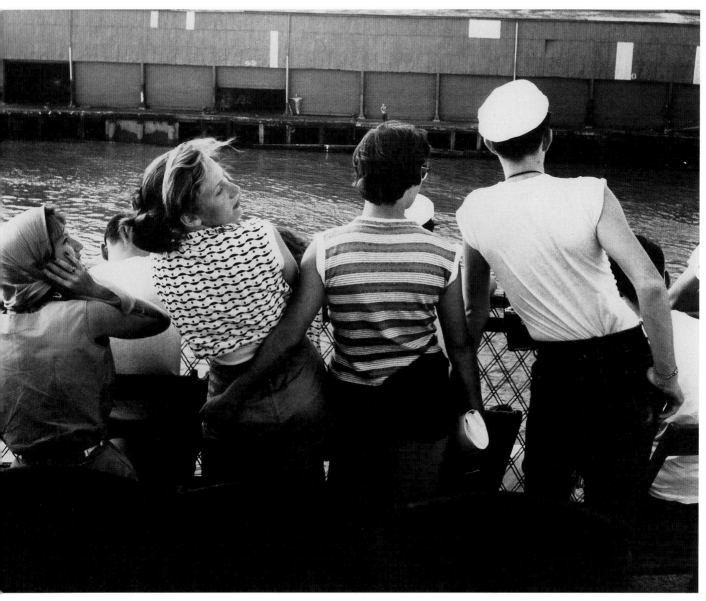

On the Mississippi, New Orleans

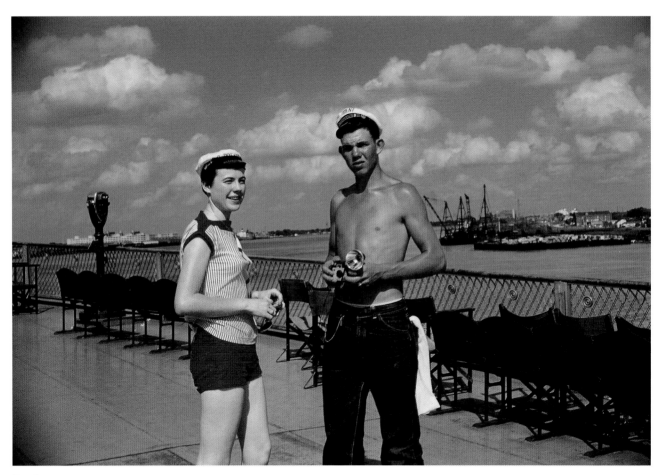

Couple

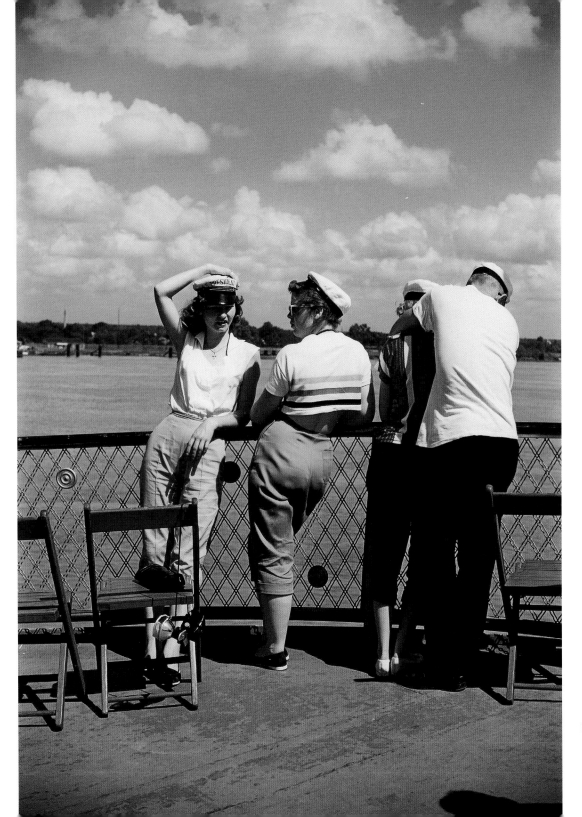

New Orleans

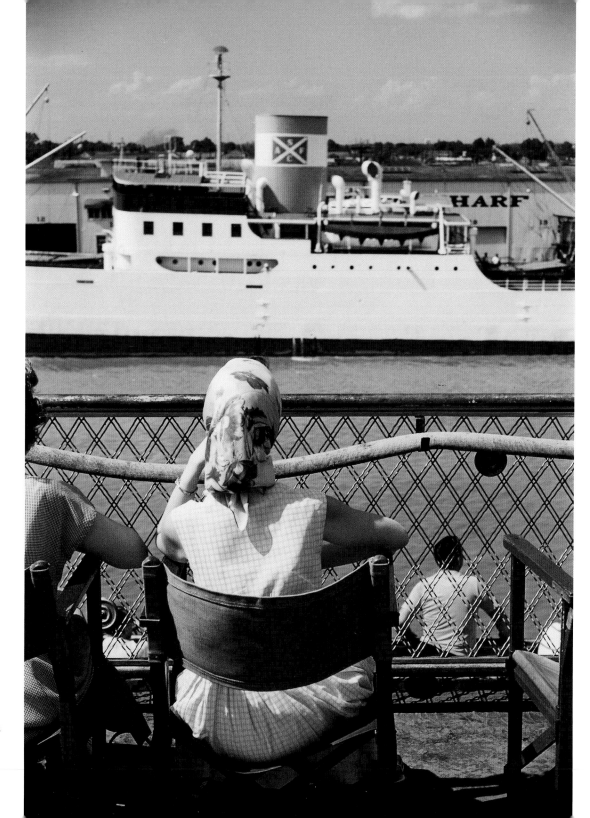

Port,
New Orleans

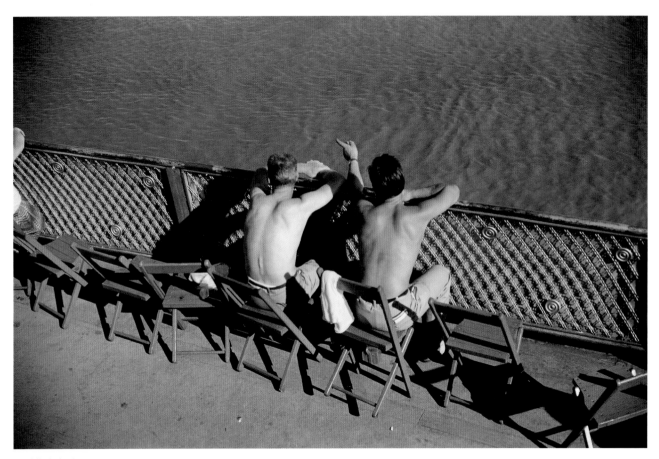

The Mississippi

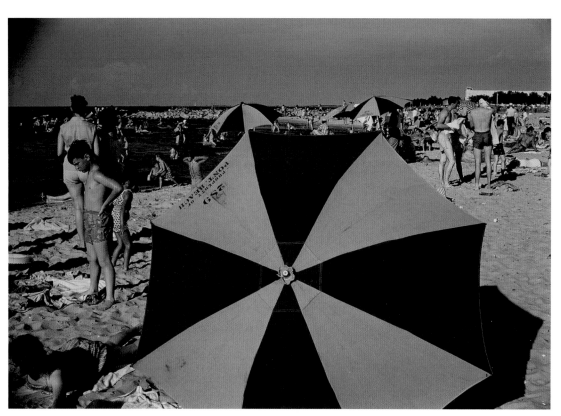
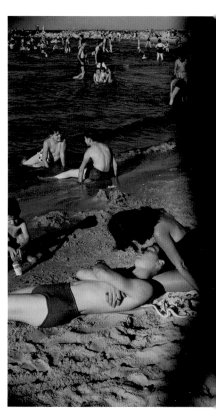

Lake Pontchartrain

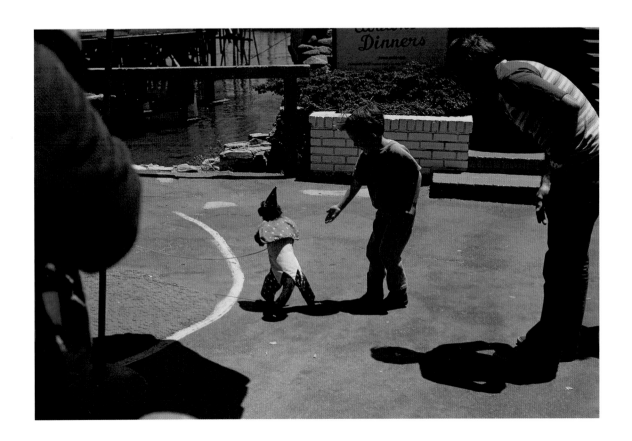

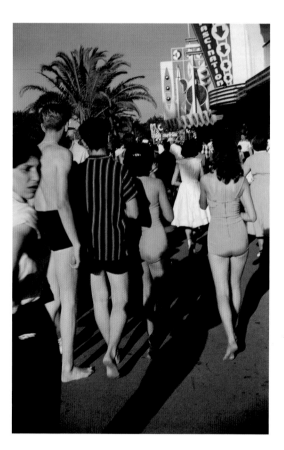 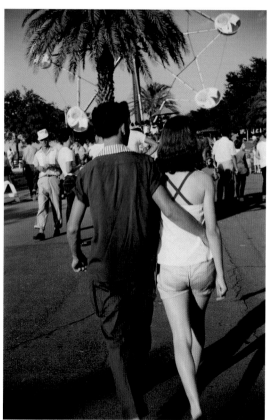 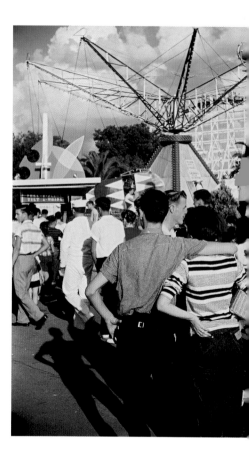

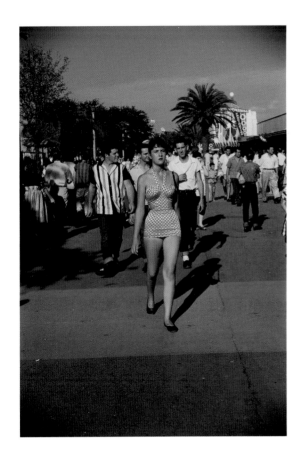

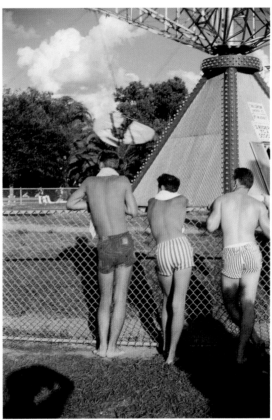

Lake Pontchartrain

125

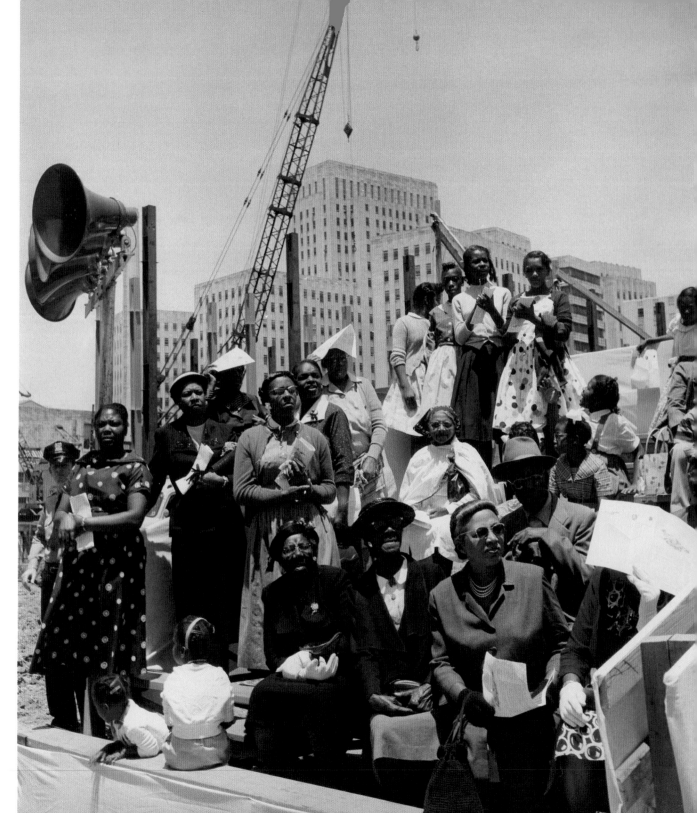

Canal Street

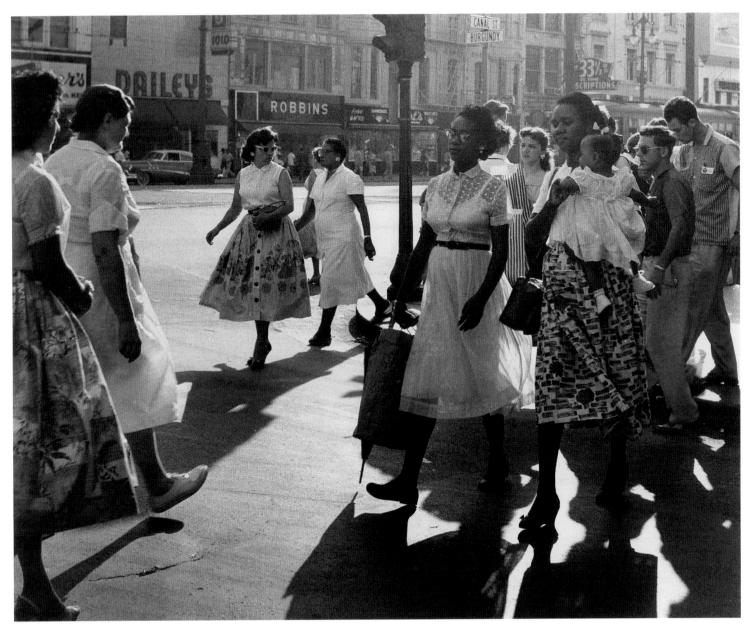

New Orleans

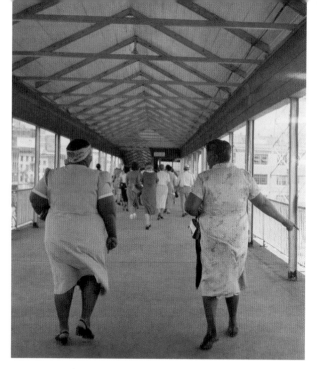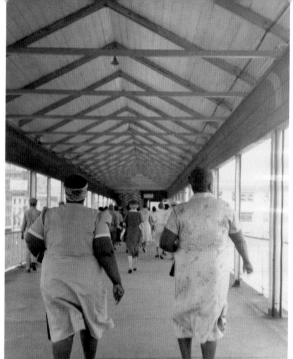
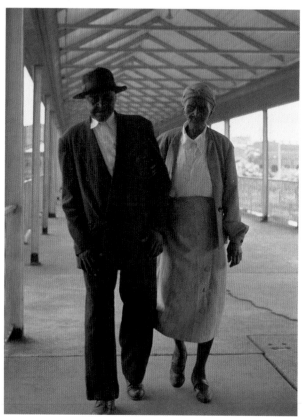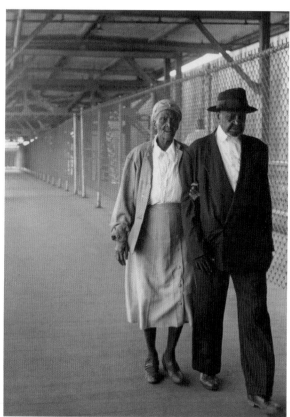

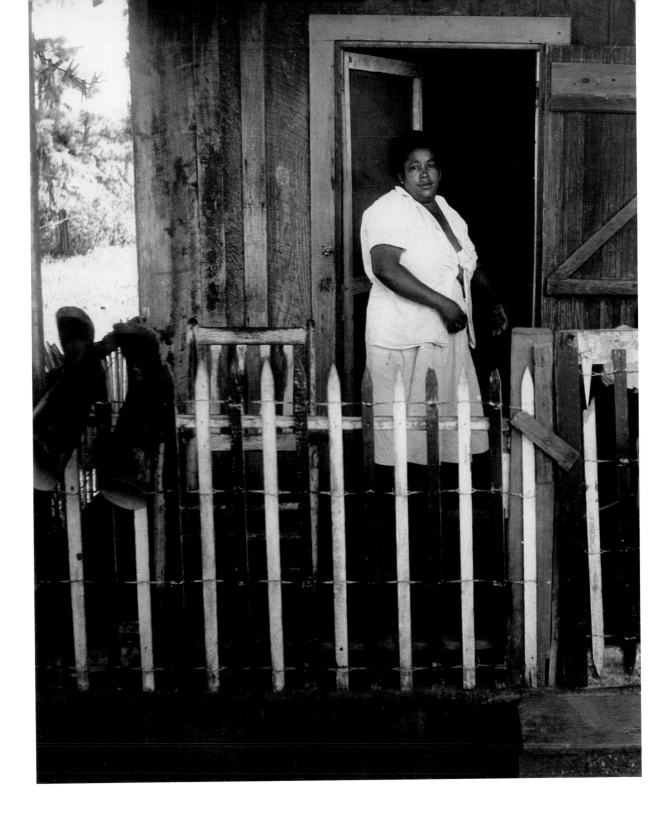

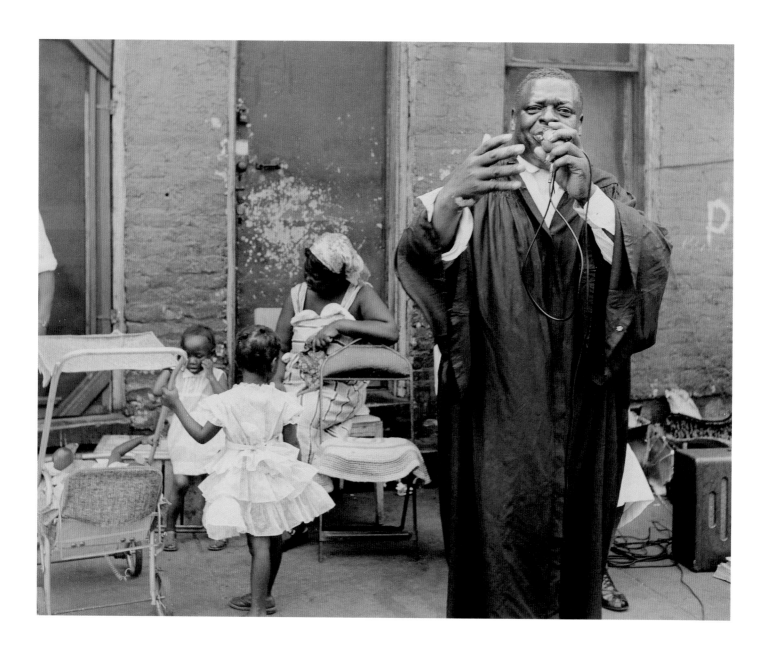

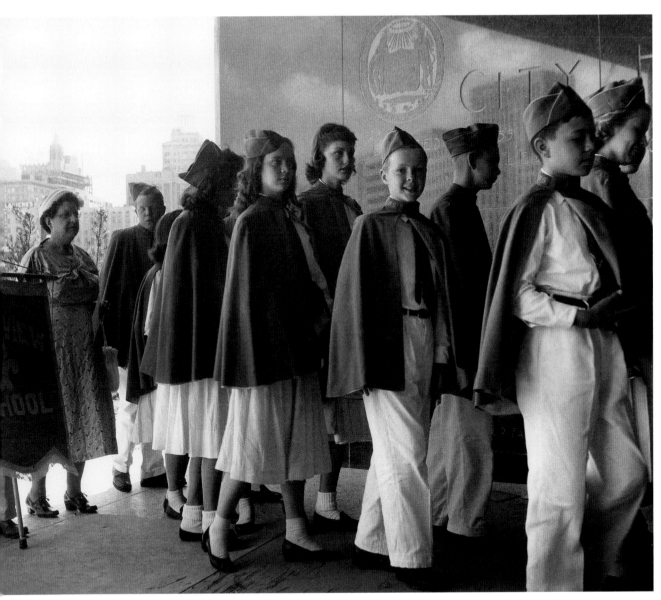

Students, New Orleans

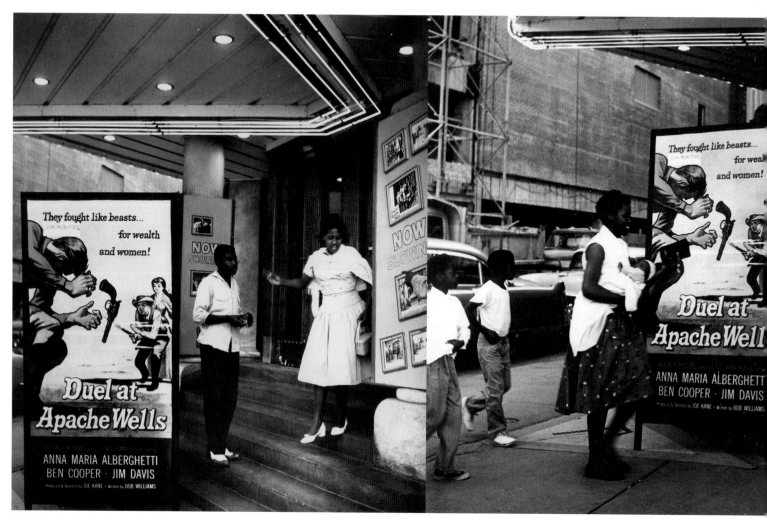

Movie theater for blacks only, New Orleans

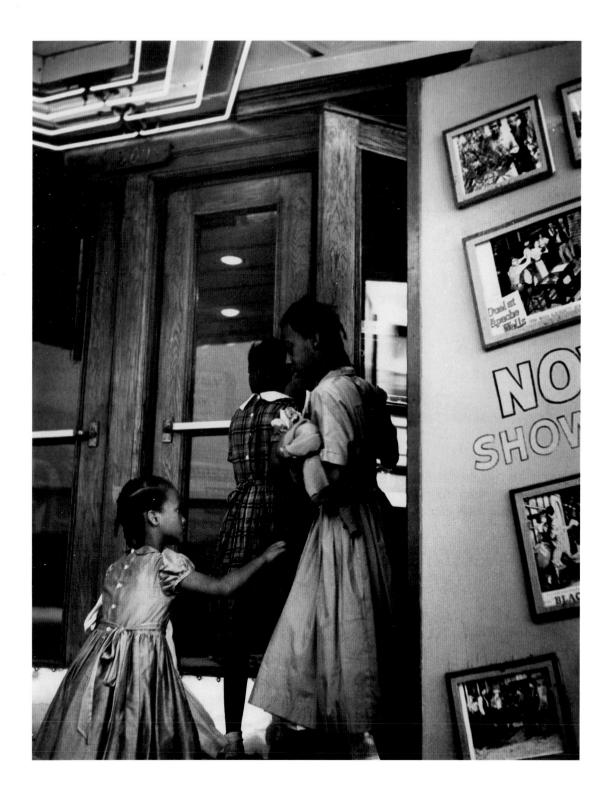

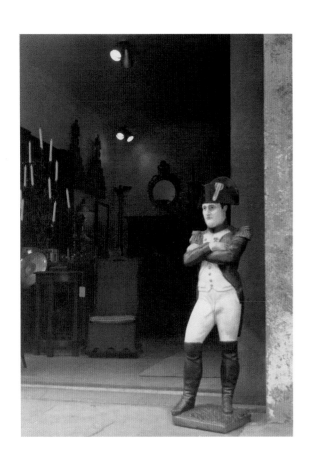
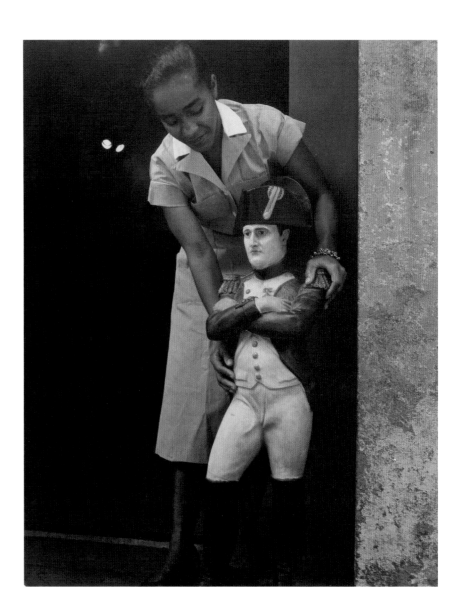

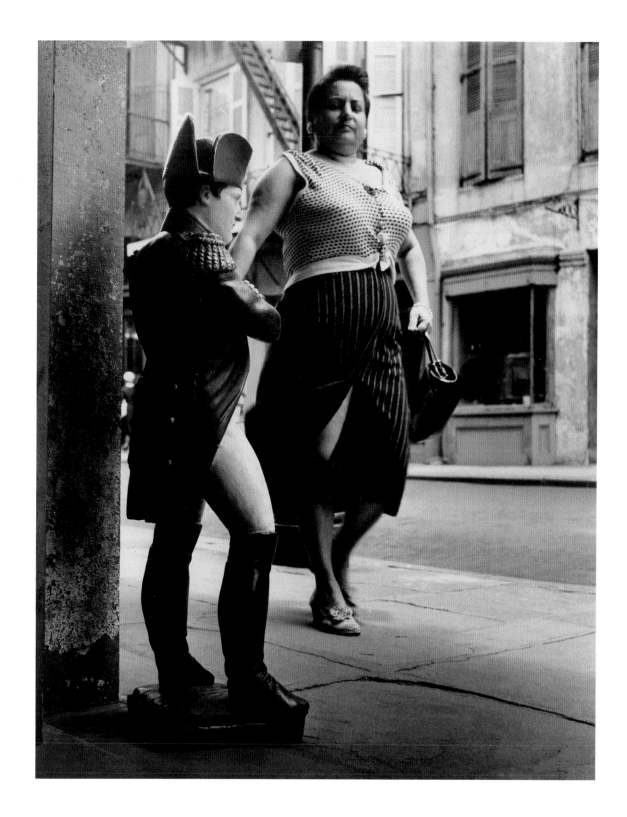

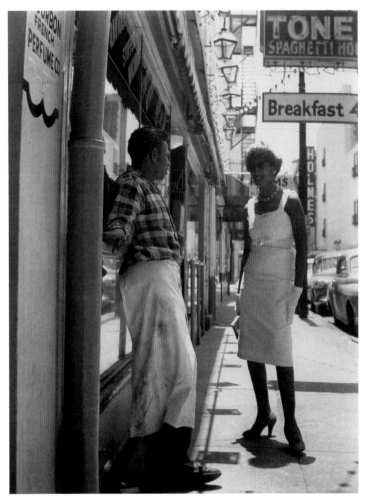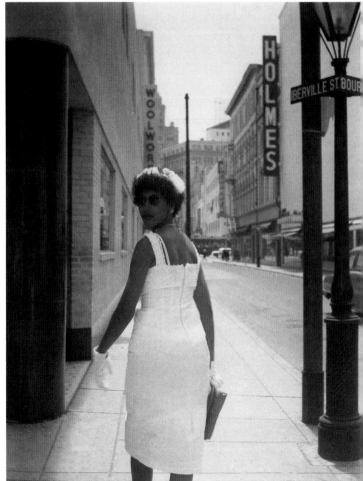

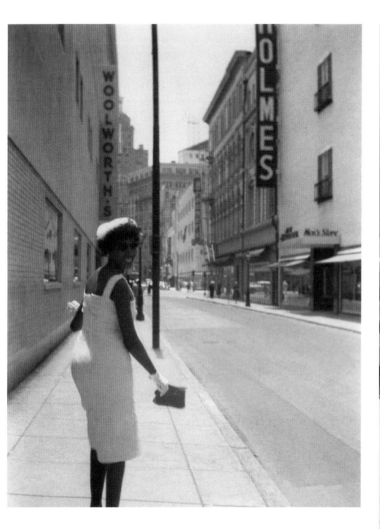
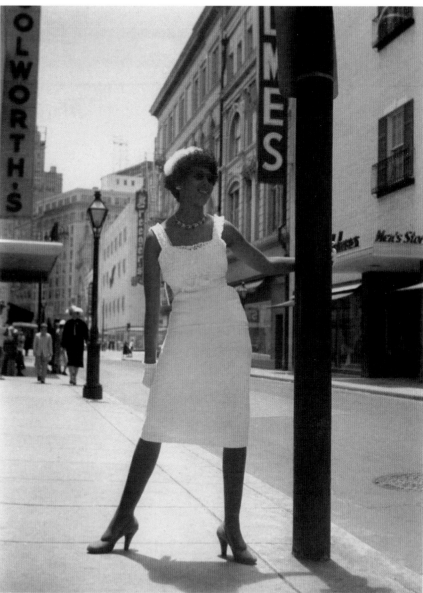

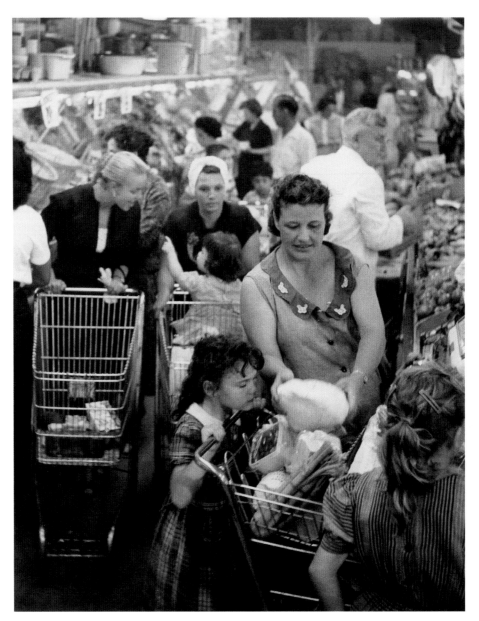

Supermarket

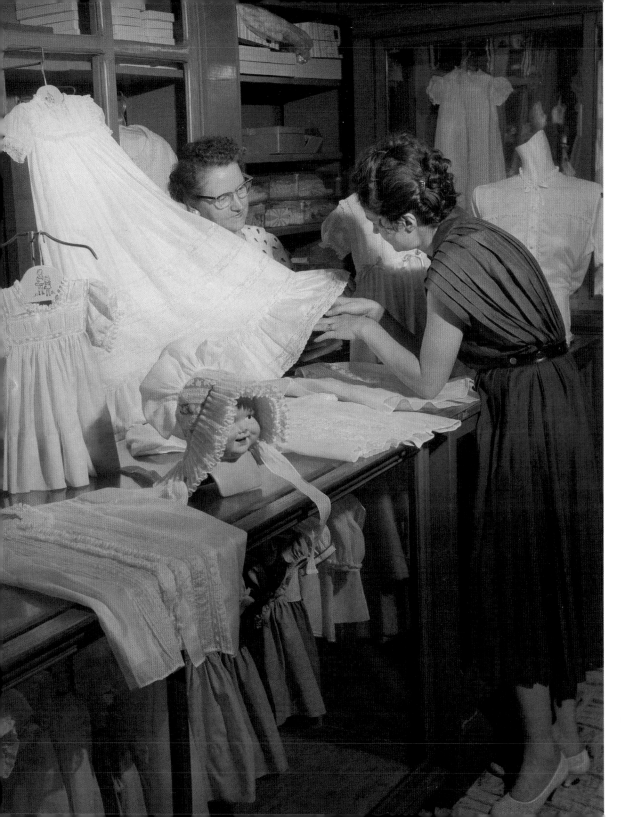

Lace-goods store,
French Quarter, New Orleans

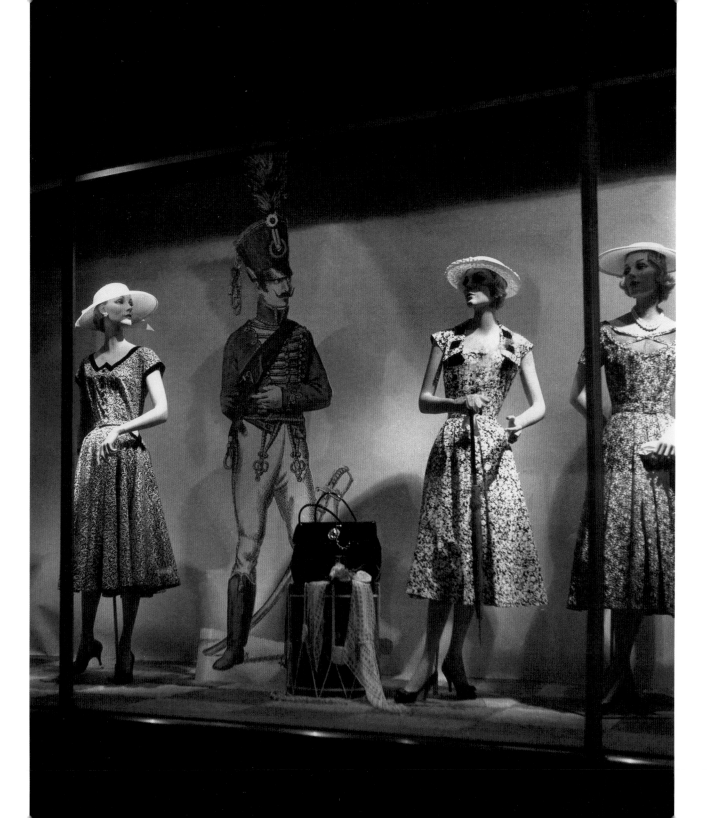

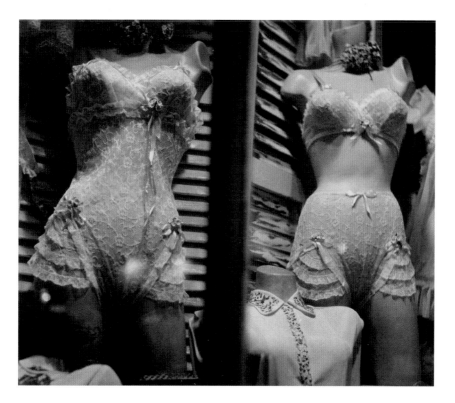

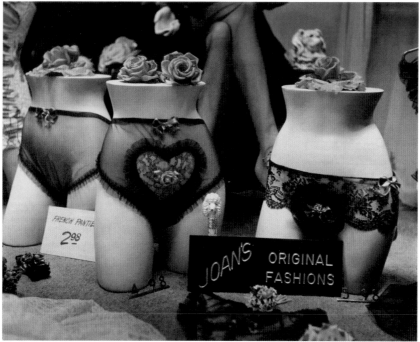

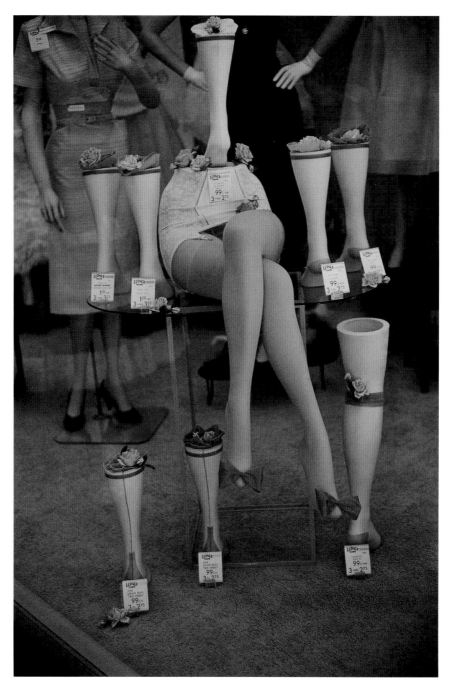

Store front

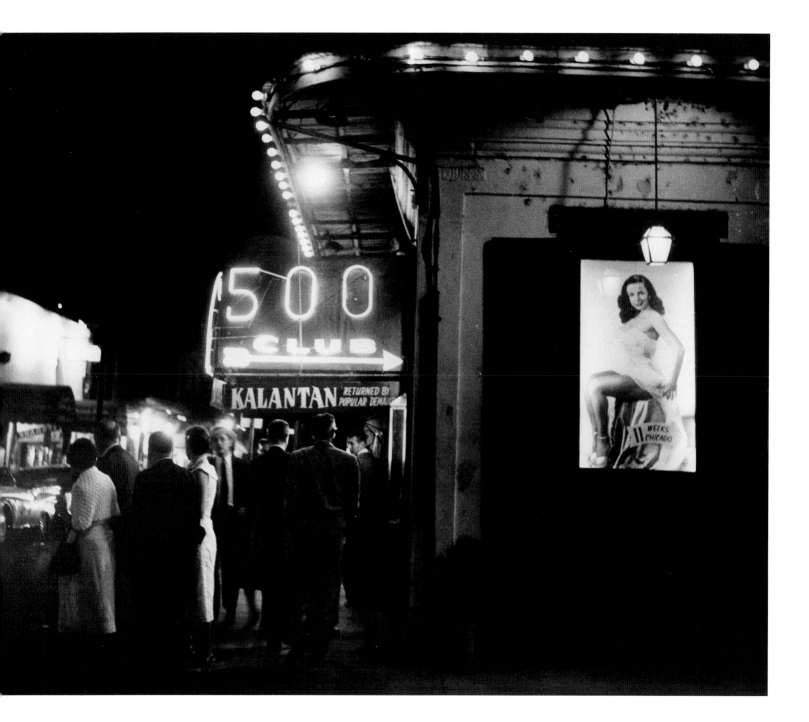

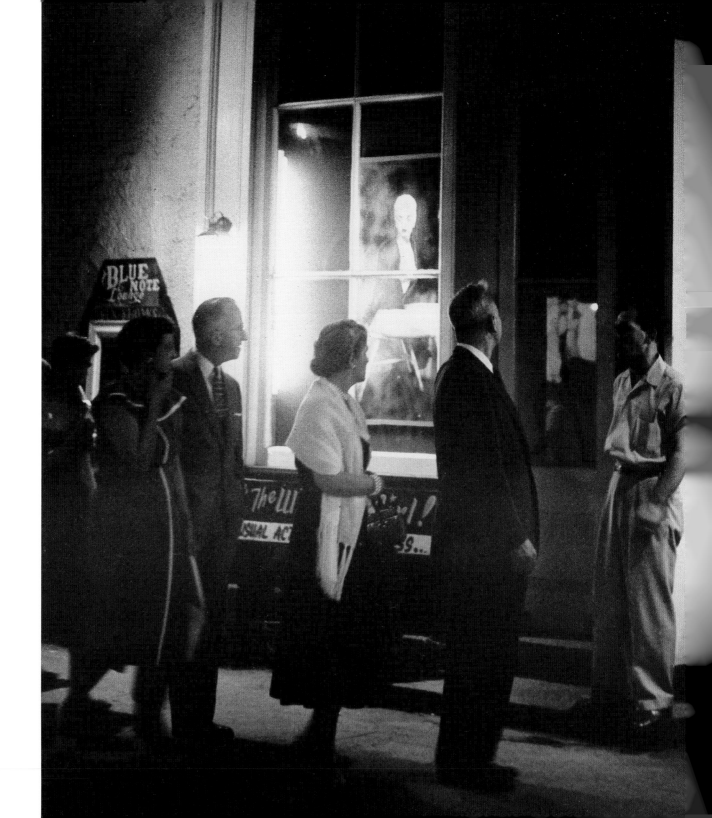

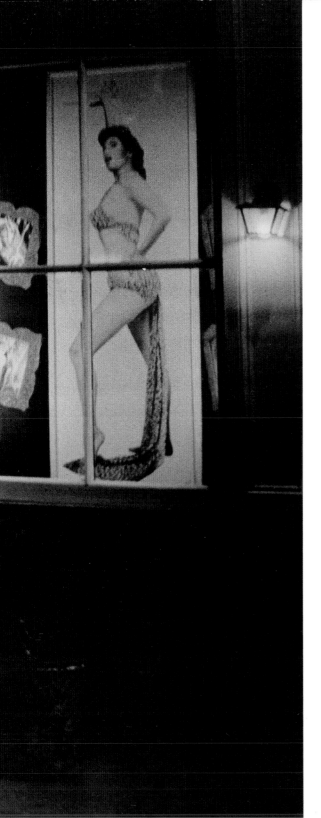
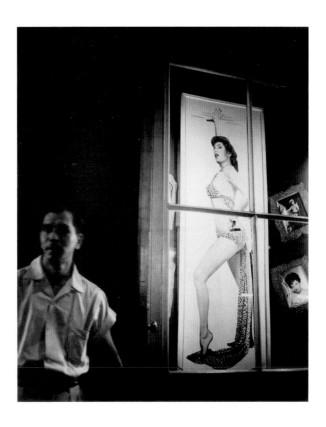

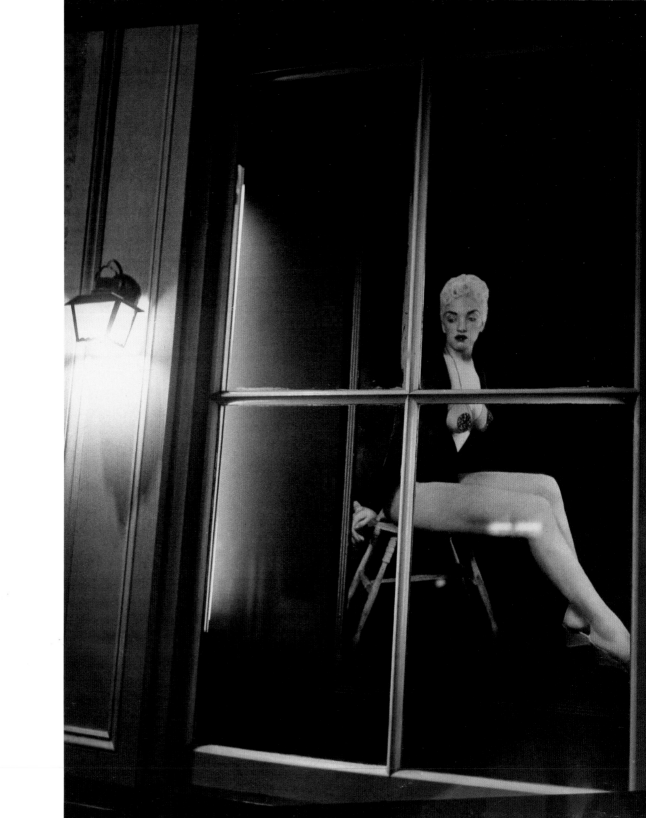

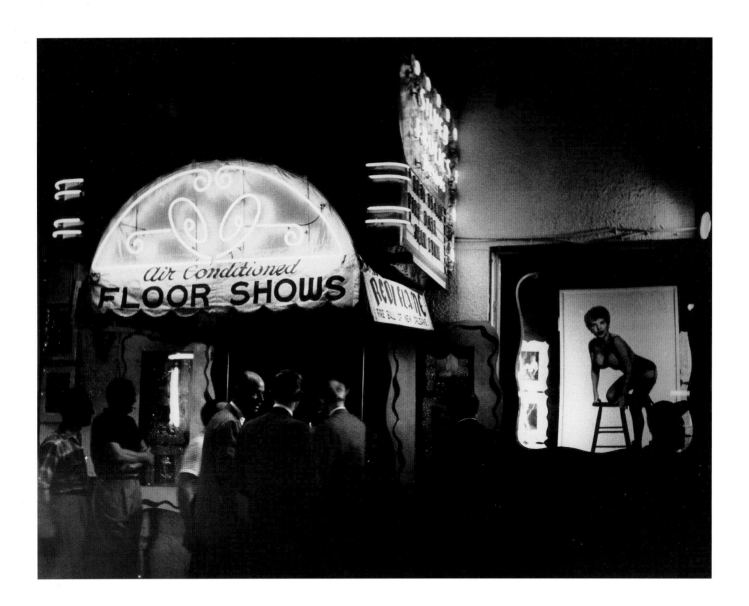

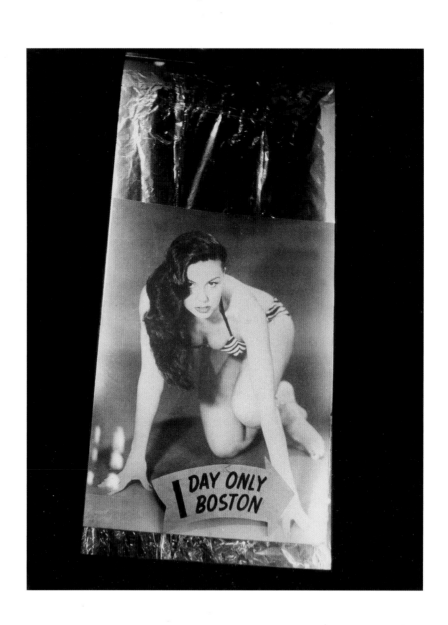

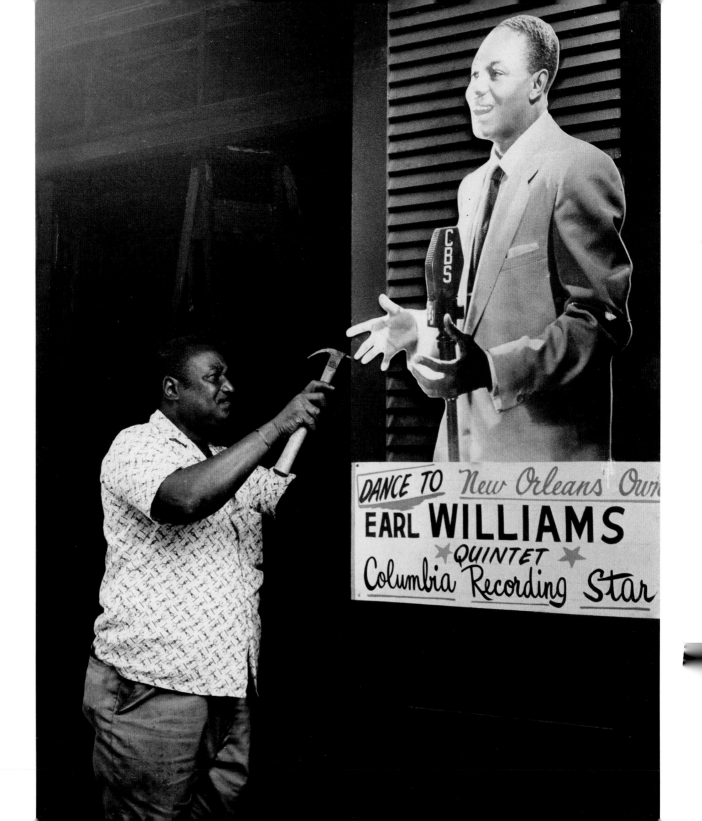

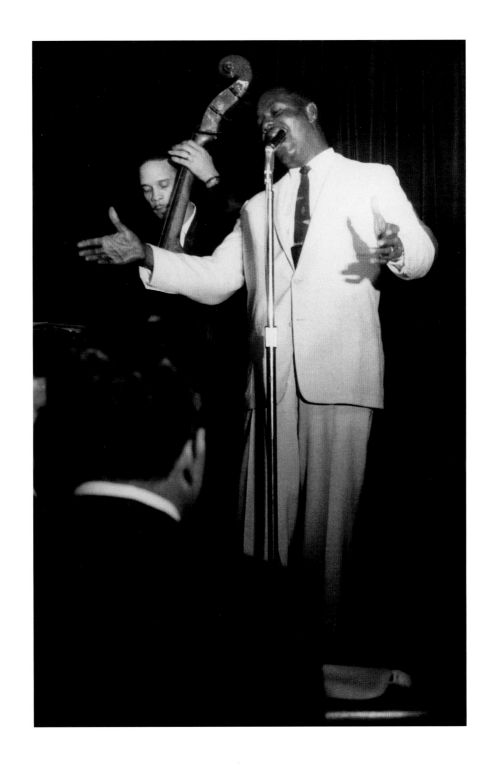

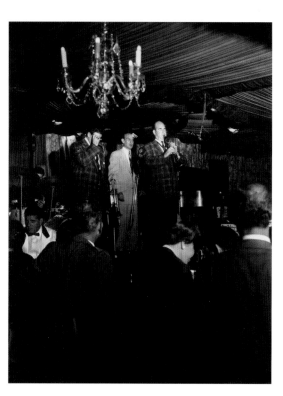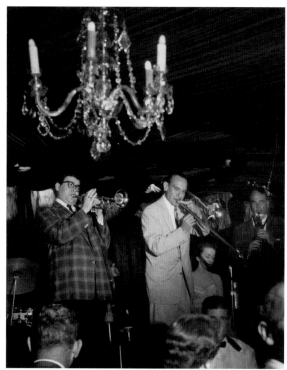

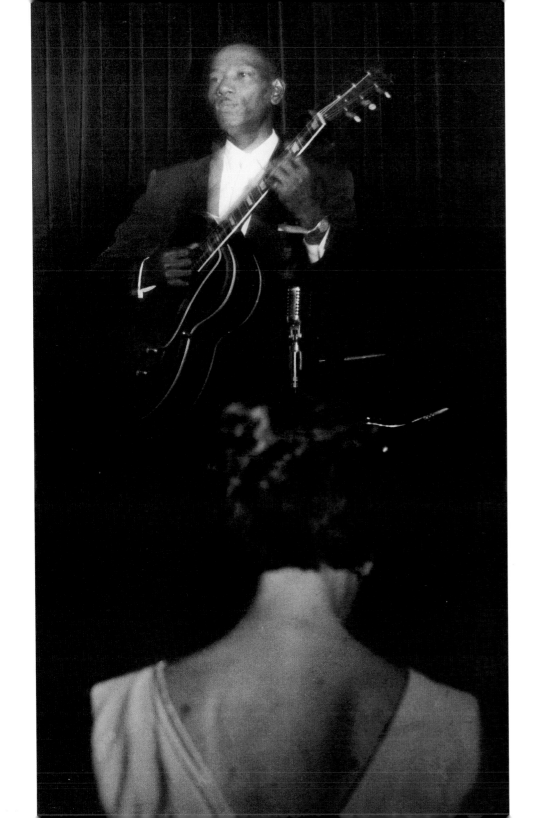

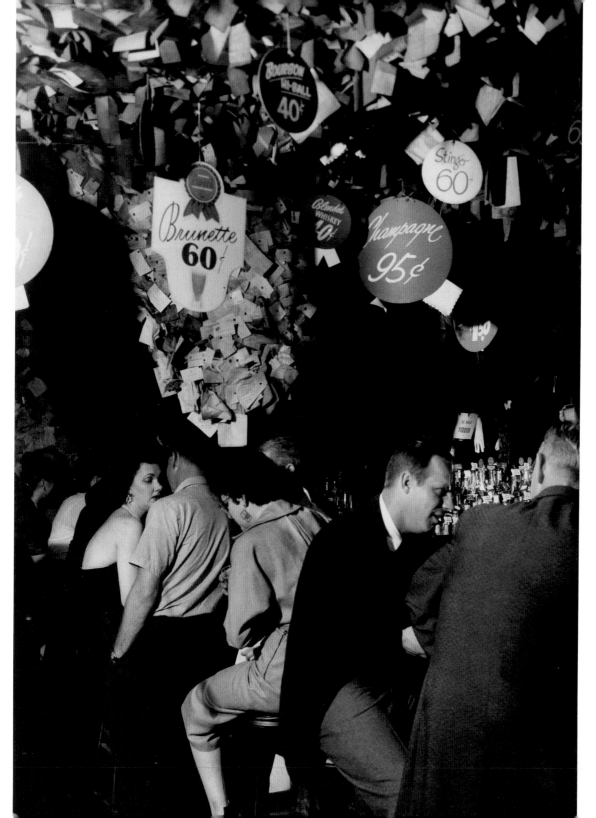

Night club, Bourbon Street,
French Quarter

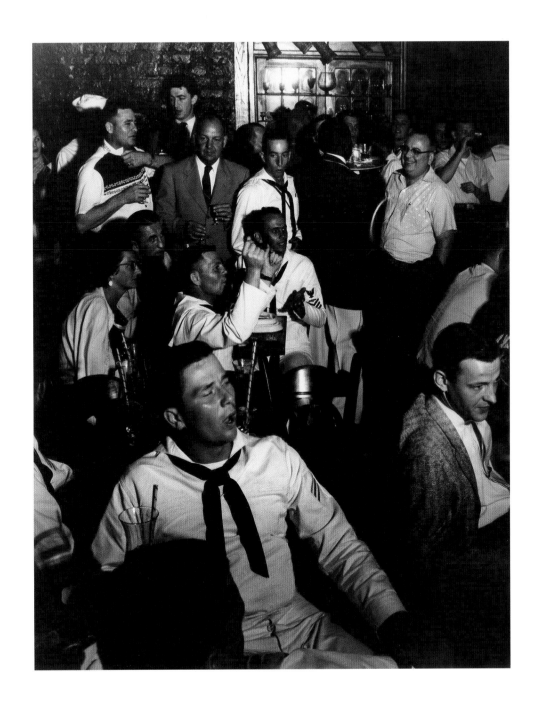

Gulf of Mexico

Biography

157

1899

Born Gyula Halász on September 9 in Brassó (Braçov), Transylvania,
a Romanian region of what was then Hungary.

1903-04

First trip to France, where his father spent a sabbatical year.

1917-18

Served in the Austro-Hungarian cavalry during World War I.

1918-19

Studied under Mattis-Teutsch at the Academy of Fine Arts in Budapest.

1921-22

Went to Berlin to enroll in the Academy of Fine Arts. Received a diploma and then attended
open studios where he met the circle of artists who would become his friends: Moholy-Nagy,
Kokoschka, Kandinsky, Tihanyi, and also the composer Varèse. He did drawings and engravings
but above all developed his artistic and intellectual approach to the world by adopting Goethe
as his mentor.

1924

Arrived in Paris in January, never to return to his home country. Spoke Hungarian and German,
and began studying French, having decided to remain in France. Became a journalist to make
a living, working for a Hungarian newspaper and German magazines. Spent his nights with
a group of artists—mostly Hungarian and German—in the heyday of Montparnasse.

1925

Met writer Henri Michaux and photographer Eugène Atget, whose pictures
he greatly admired.

1926

Met André Kertész in Montparnasse; began seeking photographs that could illustrate his articles as he pursued his career as a journalist.

1928

Moved into the Hôtel des Terrasses on rue de la Glacière, where his friends Tihanyi, Reichel, Korda, and Queneau lived.

1929

Began taking photographs, originally to illustrate his articles. Bought his first camera, a Voigtländer.

1930-31

His parents spent several months in Paris on a visit. He began systematically photographing ordinary objects (on a large scale) and then started his long series *Paris by Night*.
Set up a darkroom in his hotel room to develop his own prints.
Became friends with Alexander Calder and S.W. Hayter, then met Henry Miller with whom he would wander the streets of Paris till dawn.

1932

Adopted the artistic name of Brassaï for his photographic work. Published *Paris by Night* and went on to begin a long series on the mores of a vanishing society, later published as *The Secret Paris of the '30s*. Met the Prévert brothers, Fernand Léger, Le Corbusier, and especially the art publisher Tériade, who introduced him to Picasso and included him among the artists who were the glory of the review *Le Minotaure*.
Won a key commission from Picasso, who asked Brassaï to photograph sculptures at his country estate of Boisgeloup and his Paris studio on rue La Boétie.

1933

Worked with André Breton, Paul Éluard, Robert Desnos, Salvador Dalí, and others for *Le Minotaure* and Albert Skira. Almost every issue of the review contained either an article or photographs by Brassaï, or both.
First solo show, Batsford Gallery, London.
Spent time on the Riviera with his parents and youngest brother; took pictures of the exotic gardens in Monte-Carlo and the rocky landscape.

1934

Continued his "photographic studies of manners" for magazines yet also for more specialized publications that occasionally asked him to stage the scenes (*Détective, Paris Soir, Paris Tabou*). In London met Bill Brandt, who became one of his closest friends.

1935

Moved to the 14th arrondissement of Paris, which became the base for his photographic explorations. Set up a darkroom in his apartment.
Entrusted sales of his work to a Hungarian friend, Charles Rado, who would move to New York during the war yet remained his agent.
Hired Émile Savitry as an assistant; bought a Rolleiflex.
Met Matisse and took portrait photos of him.

1937

Began working for art directors Carmel Snow and Alexey Brodovitch at *Harper's Bazaar*, a partnership that would last more than twenty-five years.
Contributed to many French and foreign magazines such as *Vu, Verve, Labyrinthe, Coronet,* and *Réalités*, publishing both texts and photographs.

1939

At Matisse's request, executed a series of studio *Nudes,* then did a series on Picasso in his studio for *Life*.

1940-42

Fled to Cannes with the Prévert brothers and some of their group, but soon decided to return to Paris where he had left his negatives. Refused to apply for a work permit from the Germans, yet rejected an invitation to emigrate to the United States.
On Picasso's advice, began drawing again.

1943

Wrote *Bistro-tabac* about the absurdities of the Occupation era.
Picasso asked Brassaï to take pictures of the sculptures in his studio, which Brassaï continued to do into 1946; he jotted down their conversations, later published as *Conversations with Picasso*.

1944

Death of his youngest brother on the Russian front.

1945

Exhibited his drawings at the Renou & Colle gallery.
Took photographs for the sets of *Le Rendez-vous,* a ballet by Jacques Prévert.

1947

Took photographs for the set of *En passant,* a play by Raymond Queneau.

1948

Married Gilberte Boyer.
Wrote *Histoire de Marie*, with a foreword by Henry Miller. Would henceforth spend part of every year in southern France, inland from Nice.

1949

Became a French citizen.
Took photographs for the set of a play by Elsa Triolet, *D'amour et d'eau fraîche*.

1949-50
Traveled throughout Europe and the Americas for *Harper's Bazaar*.

1950
Took photographs for the set of Jean Cocteau's ballet, *Phèdre*.

1952
Death of his mother.
Publication of the first monograph devoted to his work (by French publisher Robert Delpire),
and first solo show of photographs in France (in Nancy).

1956
Made his only film, a short titled *Tant qu'il y aura des bêtes* (As Long as There are Animals,
or *Lovers and Clowns*) which won a prize at the Cannes Film Festival.
Edward Steichen hosted his *Graffiti* exhibition at the Museum of Modern Art in New York.

1957
First trip to the United States, where he took color photographs in Louisiana
for *Holiday* magazine.
Met Robert Frank and Walker Evans.

1958
UNESCO commissioned a long photographic panel, promoting the use of photography
in Paris architecture.

1960
Show of sculptures and drawing at the Pont-Royal gallery, Paris.
Completed the texts and layout for his book *Graffiti*.

1961
Began writing *Conversations with Picasso*.

1962
Showed his Graffiti photos at the Daniel Cordier gallery, Paris.

1963
Retrospective exhibition hosted by the Bibliothèque Nationale, Paris.

1964-65
Published *Conversations with Picasso*, which would be translated into twenty languages.

1967
Showed *Transmutations* at Les Contards gallery, Lacoste, France.
Began making tapestries on graffiti themes.

1968
Showed sculpture, drawings, and engravings at the Pont des Arts gallery, Paris.
MoMA in New York hosted a retrospective show of his work.
Death of his father.
Began writing an essay on Henry Miller.

1971
Showed color photos of graffiti at the Rencontre gallery, Paris.
Was commissioned by the French government to design a tapestry based on graffiti.

1972
Show of sculptures, drawings, and tapestries at the Verrière gallery, Lyon.

1973
Another long trip to the United States (Washington, D.C. and California).

1974
Guest of honor at the Rencontres Internationales de la Photographie photo festival in Arles, France.

1975
Published *Henry Miller: The Paris Years*, shortly followed by *Henry Miller: Happy Rock*.

1976
Gallimard published his *Secret Paris of the '30s*.
Awarded the rank of Chevalier de la Légion d'Honneur by the French government.

1977
Gave lectures at MIT in Cambridge and Columbia University in New York.
Published *Paroles en l'air* (Idle Talk).

1978
Awarded France's Grand Prix National de la Photographie.

1982
Publication of *The Artists of My Life*.

1983
Received a prize from the Société des Gens de Lettres for *The Artists of My Life*.

1984
Completed his book on Proust.
Died on July 7 at Beaulieu-sur-Mer.